IMPRESSIONISM

Thames and Hudson · London

© 1974 Thames and Hudson Ltd, London

Text filmset by Keyspools Ltd, Warrington, Lancs.
Litho origination by Paramount Litho Ltd, Wickford, Essex
Printed in Great Britain by Cox and Wyman Ltd,
London, Fakenham and Reading

ISBN 0 500 41054 2

IMPRESSIONISM

Impressionism is the most important thing that has happened in European art since the Renaissance, the visual modes of which it supplanted. From it virtually all subsequent developments in painting and sculpture have stemmed, and its basic principles have been reflected in many other art forms. For a conceptual approach, based on ideas about the nature of what we see, it substituted a perceptual one, based on actual visual experience. For a supposedly stable reality, it substituted a transient one. Rejecting the idea that there exists a canon of expression for indicating moods, sentiments and arrangements of objects, it gave primacy to the subjective attitude of the artist, emphasizing spontaneity and immediacy of vision and of reaction. Formulating a doctrine of 'realism' which applied as much to subject matter as to technique, it eschewed the anecdotal, the historical, the romantic, concentrating on the life and phenomena of its own epoch. Escaping from the studio, the Impressionists laid great emphasis on painting in the open air, in emotional contact with the subject which was engaging their attention. When painting in this way – and even in the studio, when the necessity to capture the *impression* of the subject they were painting was equally dominant – they evolved a technique dictated partly by the haste demanded, partly by the necessity to achieve perceptual reality. They eliminated black shadows and outlines which do not exist in nature; shadows were painted in a colour complementary to that of the object. They used a rainbow palette and experimented with various techniques of broken colour.

Impressionism was one of the first art movements to be linked with a self-conscious group; its practitioners held a number of exhibitions and intermittently acted in unity. But in fact they were very different in their personalities, and in their art; it is dangerous to dramatize their achievements by seeing them merely as idealistic revolutionaries reacting against an artistic establishment. That they seemed occasionally to be so was not integral to their achievement, and has little to do with their status as the first modern artists.

Impressionism was born in a certain social and cultural context, which was responsible for shaping its forms and determining its ideology. Most of its practitioners had grown up under the not so distant shadow of the Revolution and of Napoleon; they themselves lived through '48, the Coup d'Etat, the Second Empire, the Franco-Prussian War and the Commune, dying under the Third Republic. The background to their lives was one of constant political turmoil, with which they were necessarily involved. Mostly they were committed, with varying degrees of intensity (Pissarro was probably the most politically aware, and he was more of an anarchist than anything else), to the left. But whether they wanted to or not, the temper of the times identified them with it: to be a revolutionary in art was to be a revolutionary in everything, and the denigratory adjectives which their enemies chose to describe their work showed that this was taken to include morality as well as politics.

The enemies of the Académie were inevitably enemies of the Establishment, and though none of them professed the bellicose sentiments of Courbet, they were all suspect. By the middle of the century an implicit alliance had been established between Bohemia and the Left – an alliance which, as the events of 1968 proved, subsists into the late twentieth century. Those who fail to comprehend a new art

style see in it a threat not only to society, but also to the inner certainties of the ego.

There was not much that was subversive in the personal lives of the Impressionists; on the whole they were pillars of domestic rectitude. And it would be entirely wrong to visualize them, even in their purely professional context, as indolent dependents on the whims of creativity or the fluctuations of inspiration. Their output was prolific – sometimes even unfortunately so. They rose early and set off, their easels on their backs, through the countryside, along the banks of the Seine, or through the streets of Paris, looking for suitable sites, likely landscapes, appropriate scenes. Or they laboured in their studios as long as the light lasted.

They were sensitive to public reaction and did all they could to manipulate it in their favour. They were, almost without exception, anxious to be successful, in the most traditional, conventional way.

They grew up in the Paris of Balzac and came to maturity in the Paris of Zola, seeing its transformation under the guidance of Baron Haussmann from an archaic tangle of great palaces and untidy warrens into the luminous city of broad boulevards, luxurious hotels and verdant parks which, by choosing them so frequently as the subject matter of their paintings, they were to immortalize. For, despite the obvious evils of the nineteenth century, its latter half saw an immense improvement in the amenities of life, and nowhere was this more apparent than in the French capital. Life was easier for a large number of people than ever it had been. Social intercourse was more relaxed, and though cafés, for instance, had always played some part in the cultural life of Paris, in the nineteenth century they assumed a significance which they have never since lost. They provided an invaluable meeting-place for men of similar ideas, where the most fruitful and significant forms of contact could be established, theories propounded,

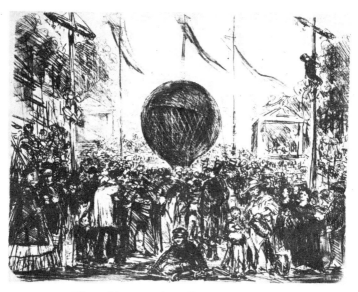

Edouard Manet. *The Balloon*, 1862. Lithograph, $16\frac{1}{8} \times 20$ (41 × 51).

programmes worked out. Cafés were of seminal importance in the creation of artistic groups – and it must not be forgotten that such groups were a comparatively new phenomenon in art, peculiar to the nineteenth century (but not of course to France, as the Nazarenes and the Pre-Raphaelites prove). The history of French art during most of the nineteenth century could be written in terms of cafés: the Brasserie Andler, where Courbet used to preside; the Café Fleurus, with panels decorated by Corot and others; the Café Taranne, patronized by Fantin-Latour and Flaubert; the Nouvelle-Athènes, where Manet, Degas, Forain and Lamy were often to be found; the Café Guerbois, which more than any other place could claim to have been the birthplace of Impressionism.

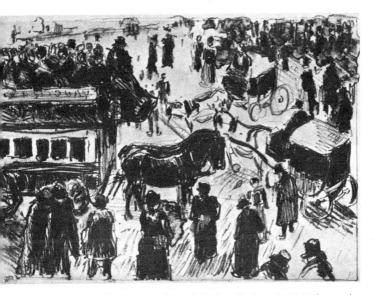

Camille Pissarro. *Place du Hâvre, Paris*, c. 1897. Lithograph, $5\frac{1}{2} \times 8\frac{1}{4}$ (14 × 21).

These changes in the landscape of French and especially Parisian life were closely linked to social changes. The industrial revolution generally, and in particular the real-estate boom in Paris consequent upon the policies of Napoleon III, had created an immense amount of new wealth, most of it possessed by newcomers to affluence. Unversed in the older traditions of patronage, it was they who were largely responsible for the sudden emergence in the nineteenth century of the art dealer. Till then art dealing had been a haphazard business, more highly developed, for historical reasons, in Holland than elsewhere. But by the 1860s a new breed had emerged in all the European capitals. Housed in prestigious premises, able, and indeed eager, to advise and direct both artists and customers, acting as impresario,

accountant and public relations officer combined, the dealer provided a new and significant service. He liberated artists from their dependence on the annual official Salon; he opened up new outlets; without him the avant garde would never have existed. This effective influence was especially true for Impressionism, which owes an incalculable debt to the perspicacity, good sense and loyalty of Paul Durand-Ruel and Ambroise Vollard, the movement's main dealers.

The art market was, in fact, expanding at an unprecedented rate – not only because there was more money about. Education was improving; the application of the steam engine to the printing press led to a proliferation of cheap books, and to the emergence of a multiplicity of journals and newspapers. The invention of lithography, the production of cheap chromolithographic prints, advances in the techniques of producing line blocks – leading eventually to the application of photographic processes – all produced a growth of visual sophistication and of knowledge not only about the art of the past, but about that of the present. An inevitable concomitant was that much more was written about art than ever before. The art historian and the critic emerged as figures of significance. The latter, of course, was especially important in the context of contemporary art. The public was hungry for guidance, and it is probable that current exhibitions in the Paris of the 1870s received more coverage than they do in Paris of the 1970s. Even hostile criticism was probably better than none, though it is now becoming increasingly apparent that hostility to the Impressionists was by no means universal. The support of Zola, even though based at times on erroneous assumptions, was invaluable.

Further, Impressionism also owed its historical validity to the fact that it reflected the profound changes taking place in the whole of European culture. The colour theories of the polymath chemist Eugène Chevreul (1786–1889) had been published before the

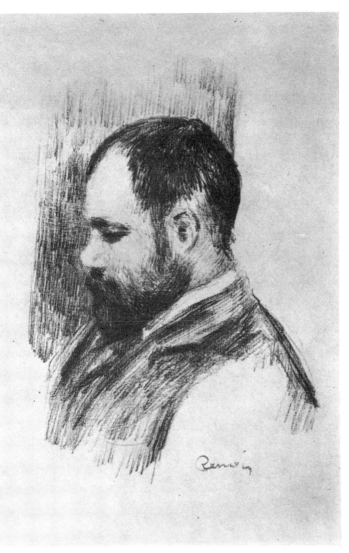

Auguste Renoir. *Ambroise Vollard*, 1902. Lithograph, $9\frac{3}{8} \times 6\frac{3}{4}$ (23.8 × 17.2).

Impressionists began to paint, though it would seem that they did not really begin to apply them until the 1880s, in conjunction with associated discoveries made by Helmholtz and Rood. The more significant point is that the scientists and the artists were moving in the same direction, towards a realization that colours were not, as Leonardo and Alberti had believed, immutable realities but depended on individual perception, that they were part of the universe of light, one of the elementary dimensions of nature. Unlike the traditionalists in both fields, the new breed of scientists and artists could no longer believe in the existence of a permanent, independent, unchangeable reality which could be controlled by perspective or Newtonian physics – a hypothesis which had done much to allay the anxieties of Western man since the Renaissance.

Unconsciously, they were moving towards a concept of the nature of matter which was to find expression half a century later in the discoveries of Einstein. In this context their concern with time – this is, of course, especially true of Monet, who eventually endeavoured to relate light, time and place in a sequence of serialized images of cathedrals and lily ponds – is especially significant. The advent of the machine, with its fixed temporal rhythms and the demands it made on its users to comply with them, had fostered an obsessive concern with time, symbolized by the vast proliferation of clocks in public places which took place after about 1840, by the emergence of history as a dominant discipline, and by the appearance of systems such as the Darwinian and the Marxist which were essentially time-orientated.

But if time and light were one series of preoccupations which affected the nature of Impressionism, speed, the combination of time and space, was another. Till the popularization of the railway engine in the 1830s and 1840s, nobody had experienced travelling

at more than about 15 miles an hour. To see objects and landscapes from a train travelling at 50 or 60 miles an hour emphasized still further the subjective nature of visual experience, underlying the transitory, blurring the precise outlines to which post-Renaissance perspectival art had accustomed the artist's eye, and unfolding a larger, less confined view of landscape. Even the increased ease of transport was significant. The Impressionists opened up the South of France as a source of inspiration; they travelled more extensively than any other group of artists had been able to in the past; their work was nourished by a greater variety of landscape.

There were other technological discoveries of their time which influenced them. Chemistry was extending the range and improving the quality of pigments available to the artist (chemical pigments are purer and more stable than their organic equivalents); paper and other materials were cheaper and generally better. Most important of all, however, was the influence of what had originally been called 'the pencil of nature' – the camera. Its impact on art generally, and on Impressionism specifically, was enormous.

In the first place, the camera then had none of the pejorative 'mechanical' associations with which it was later to be endowed. In 1859 the Salon included a photographic section, and in 1862, after a prolonged legal battle, the courts declared photography an art-form – much to the chagrin of Ingres. His reaction was understandable: the camera was to abrogate one of the, admittedly minor, functions with which artists – especially of his type – had always been entrusted: as documenters of events and appearances; the result, of which the Impressionists must have been half-consciously aware, was to allow painting to be itself, to emancipate it from the necessity of referring to a concept of external reality as an inescapable criterion. Art had achieved a self-sufficiency which in the past had always eluded it.

But the Impressionists – and in this they were not unique: many of their more academic contemporaries had come to the same realization – were aware that photography had made an important contribution to the painter's technical armoury. It enabled him to get a steadier and more continuous look at appearances; it permitted analyses of the nature of structure, and of movement, of a kind which had never been possible before. Photography and the new art were natural allies: the first Impressionist exhibition was held in the premises just vacated by Nadar (Félix Tournachon), photographer, cartoonist, writer and balloonist. Much of Eadweard Muybridge's work in the photographic analysis of movement was carried out in France, where he had worked in collaboration with the painter Meissonier, and it was widely known and discussed in artistic circles. Himself an ardent photographer, Degas saw the publication of Muybridge's instantaneous photographs in *La Nature* in 1878, and thereafter followed his work closely (A. Scharf, 'Painting, Photography and the Image of Movement' in *The Burlington Magazine,* CIV, 1962, pp. 186–95), not only being influenced by it in a general way, but making drawings and sculptures from some of the plates in Muybridge's *Animal Locomotion.*

In his work on *Degas, Manet, Morisot,* Paul Valéry summed up some of the perceptual consequences of this new technical 'eye': 'Muybridge's photographs revealed all the mistakes which painters and sculptors had made in depicting, for instance, the movements of a horse. They showed how creative the eye is, elaborating on the data which it receives. Between the state of vision as mere *patches of colour* and as *things* or *objects,* a whole series of mysterious processes take place, imposing order on the jumbled incoherence of mere perception, resolving contradictions, reflecting prejudices which have been formed in us since infancy, imposing continuity, connection, and

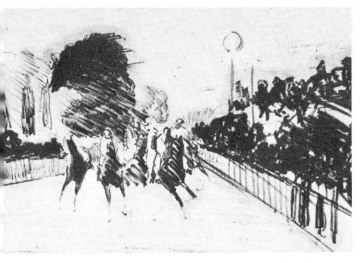

Edouard Manet. *The Races*, 1864–65. Detail. Lithograph, $14\frac{1}{8} \times 20$ (36 × 51).

the systems of change which we classify as *space, time, matter* and *movement*. That is why the horse was supposed to move in the way the eye seemed to see it, and it might be, if that old-fashioned method of representation was studied with enough percipience, we might be able to discover the *law* of unconscious falsification which enabled people to picture the positions of a bird in flight or a horse galloping, as if they could be studied at leisure.'

Implicit in Valéry's notions are many of the aims and preoccupations of the Impressionists. Moreover, the vision of the camera incorporated that very element of immediate spontaneity which had become such a desideratum. It froze gestures, immobilized a movement in a street, fixed for ever a dancer's pirouette. It conveyed a form of truth: it was real, and the Impressionists were above all else Realists – not only

in their choice of subjects from everyday, ordinary life and everyday, ordinary people, but in their determination to be visually sincere, not to vamp up the things they saw, not to paint them as they *thought* they were, but as they actually were. Zola, writing in 1868 about Monet, Bazille and Renoir in his *Salon,* called them *Actualistes*: 'Painters who love their own times from the bottom of their artistic minds and hearts. . . . They interpret their era as men who feel it live within them, who are possessed by it, and happy to be so. Their works are alive because they have taken them from life, and they have painted them with all the love they feel for modern subjects.'

The vision of the camera was an enormous incentive in this direction. And it influenced not only the Impressionists' attitudes but their style. Time and time again the composition of their paintings imitates, or is influenced by, the arbitrary, unselective, partly random finality of the photograph. No longer is there the academic insistence that the subject should be coherent, complete and seen from a compositionally convenient viewpoint. The unity is now in the painting, and in the elements which compose it. Figures may be truncated, poses awkward and ungainly, movements arrested. Chance has entered into painting, to be controlled, manipulated, but still to retain a dominance which it can never lose.

It would, of course, be absurd to see Impressionism purely as the by-product of social, scientific and historical factors. It was rooted firmly in the stylistic evolution of art. Always we are tempted to over-dramatize history, and though Impressionism was indeed the nucleus of the new and the revolutionary, we see it now as more closely related to the art of its own time than the simplifications of criticism once seemed to demand. The Pre-Raphaelites, for instance, though they adopted a different technique, were equally concerned with visual and social realism; the cult of 'sincerity' was widespread, and had been

formulated by Ruskin; the academic Meissonier's light, nervous brush-stroke was not unlike the *facture* of many of the Impressionists in the late 1860s, and round about this period Millet's paintings began to palpitate with a hitherto unfamiliar light.

Though they rejected official art, the Impressionists owed an allegiance to some of their immediate predecessors. Manet's teacher Thomas Couture, though apt to paint pictures of decadent Romans, suggested that artists of the future might find as appropriate themes workers, scaffolding, railways (*Méthodes et entretiens d'atelier*, Paris, 1867, p. 254) and there was a whole tradition – of what might be called potential avant-garde painters – which contributed significantly to the techniques and ideology of Impressionism. Delacroix, with his romantic fervour and liberated attitude towards colour, was an obvious idol. So too was Courbet, who once said 'Realism is Democracy in art', and whose life-style as well as his actual work had a very marked influence, especially on Pissarro and Cézanne.

The real achievement of the Impressionists is that they gave coherence and form to tendencies which had for some considerable time been latent in European art. Turner and Constable, for instance, whose influence is discussed later, had been concerned with many of the same problems about light, colour and the approach to a 'realistic' interpretation of landscape. The whole of the Barbizon school had been painting out of doors (*au plein air*) since the 1840s, even though they usually completed their paintings in the studio. Narcisse-Virgile Diaz (1807–76) had been one of the most forthright opponents of 'the black line' in painting, and his exercises in capturing the effects of sunshine coming through the dark greens of the forest, all expressed in a heavy impasto, contained obvious elements of Impressionism. It was he who, meeting Renoir painting in Fontainebleau, said, 'Why the devil do you paint so black?' – a remark which

had an immediate effect on the younger artist's palette – and who, incidentally, allowed Renoir to buy painting materials on his account. Théodore Rousseau (1812–67), who expressed the ideal 'always to keep in mind the virgin impression of nature', carried an interest in the rendering of atmospheric effects to a point where it came close to Monet. The sense of poetry, the compulsion to reproduce scrupulously what he saw, and the light silvery tonality of Corot (1796–1875) had an obvious impact, and the luminous Northern seascapes of Eugène Boudin (1824–98), with their vivacious directness, their creamy impasto and their radiance, made it almost inevitable that, though not an 'official' Impressionist, he should participate in their first group show.

There were other artists outside of France who anticipated Impressionism, or followed similar lines of approach. Outstanding among these are the Germans Adalbert Stifter (1805–68), who was also a poet and stumbled almost accidentally on those qualities of visual sincerity and spontaneity typical of the movement, and Adolf Menzel (1815–1905), whose mastery of light was only appreciated after his death. The Dutchman Johan Jongkind (1819–91) was virtually a Parisian, and though he did not practise *plein-air* painting, he was obsessed with representing in his works not what he knew about the subject, but what appeared to him under certain atmospheric conditions. It is interesting that in an article in *L'Artiste* in 1863, the critic Castagnary said of him: 'I find him a genuine and rare sensibility. In his works everything lies in the *impression* [my italics].'

The art of the past was revealed to painters of the mid-nineteenth century in a way which would have been impossible before. Till the 1840s museums and art galleries were few and far between, but between then and the end of the century they proliferated at an extraordinary rate. Sisley, Monet and Pissarro saw

the works of Turner, Constable and others in London's National Gallery, which was then only a few decades old. Every provincial city of importance acquired its cultural institutions, and, in ever-increasing numbers, works of art which had once belonged to private collectors found their way into public collections, where they were described and analysed by critics as perspicacious as the painter Eugène Fromentin and others. It was through these innovations that the Impressionists became conscious of, and reacted to, a whole range of old masters, from the early Renaissance painters to Dutch landscapists such as Ruysdael, all of whom gave sanction to their visual explorations and enlarged their range. The Louvre, of course, had been in existence for some time as a public gallery, and its treasures had been greatly enlarged by Napoleon. But even here an important innovation took place in the 1830s, under the reign of Louis-Philippe, when in consequence of that monarch's dynastic preoccupations with Spain, the gallery acquired an important collection of paintings by hitherto little-known artists such as Velázquez, Ribera and Zurbarán, all of whom were to have an enormous impact on the painters of the 1870s. In 1851 Napoleon III reopened the newly rearranged galleries, which had been enhanced by the addition of the Rubens *Medici* cycle. Despite the contrary image of him which has grown up, Napoleon III's administration of the governmental Beaux-Arts department was far more enlightened and progressive than anything else of the same nature in Europe. Special copying facilities were provided at the Louvre, the Palais du Luxembourg was given over to contemporary art, and it was, after all the Emperor himself who initiated the Salon des Refusés in 1863.

Another new set of influences came from outside Europe. As far back as 1856 Japanese art had started to infiltrate into Paris, and six years later Madame Soye, who had lived in Japan, opened a shop, 'La

Porte Chinoise', in the Rue de Rivoli; the simple colours and summary treatment of light and shade which were to be seen in the prints of Hokusai and others began to have their effect on a number of artists including Whistler, Rousseau, Degas, and later Van Gogh and Gauguin.

Edouard Manet (1832–83), too, was intrigued and influenced by this revelation from the East, but that is not surprising, for though the accidents of history forced on him the role of the great innovator, and the *maître d'école* of Impressionism, few painters have paid more attention to the art of the past and of their own time. His most famous painting, *Le Déjeuner sur l'herbe* (Louvre) of 1863, which when it was exhibited at the Salon des Refusés aroused a storm of ridicule and controversy (which effect may not have been entirely foreign to his intentions), was based on a Giorgione and on a Renaissance print of a painting by Raphael; the equally controversial *Olympia* (Louvre) was clearly painted under the direct influence of Titian, and many of his compositional themes were borrowed from his contemporaries, especially Monet and Berthe Morisot. Popular prints also provided for him a frequent repertory of imagery, and the kind of subject he so often chose, rag-pickers, barmaids, actors, crowds enjoying concerts, were the staple of many illustrated magazines of the period (cf. A. C. Hanson, 'Popular Imagery and the Work of Edouard Manet', in Finke; see 'Further Reading', p. 60). He was an assiduous frequenter of museums in the Low Countries, Austria, Germany and Italy as well as France and Spain, and it was the influence of Velázquez and Goya which informed those of his early paintings – often with the appropriate Hispanic theme – such as *Lola de Valence* (Louvre) which had a modest popular success, based on the same wave of public interest in the peninsula which Bizet so successfully exploited in *Carmen*.

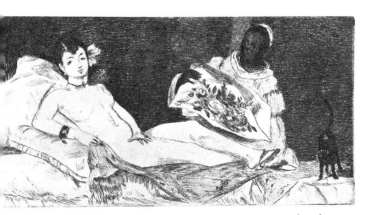

Edouard Manet. *Olympia*, 1866–67. Etching, $3\frac{3}{8} \times 6\frac{3}{4}$ (8.5 × 17.2).

Almost in spite of himself, Manet had become to the young artists of the Café Guerbois and the Atelier Gleyre a symbol of revolt, a Robespierre of art. It was his subject matter which appealed at least as much as his free and inventive technique. *Music at the Tuileries,* painted at about the same time as *Le Déjeuner,* emphasized the quality of direct observation of an ordinary urban event, packed though it is with portraits of the painter's friends, and related though it probably is to an engraving of a military band recital which appeared in the magazine *L'Illustration.*

Towards the end of the 1860s, however, Manet began to paint in the open air, and he transferred his attention from exploiting to exploring the effects of light and colour. But he was never entirely to lose the sharp contrasts of light and shade, the sensuous brushwork, the feeling of drama, the flattened volumes which he had derived from the Spaniards, and which are to be seen so vividly present in the *Eva Gonzalès Painting* (National Gallery, London). His sense of the discipline of art persisted despite the

freedom which his painting acquired as he came into closer contact with the work of his admirers (he did not participate in the Impressionist exhibitions), especially Monet and Renoir, to whom, paradoxically, he owed so much. This contact was most fruitful between 1874 and 1876 when he worked with them at Argenteuil, where he painted, among many other 6-7 similar themes, the *Boating,* now in the Metropolitan Museum, New York. Here, despite the limpid colour, the free handling and sense of spacious luminosity, there is a sense of linear control, a complex handling of the compositional elements. Here, and in the 10 *Waitress* of 1878, the structure is intellectual, the 8-9 handling instinctive. The same is true of the *Bar at the Folies-Bergère,* painted a year before he died and at a period when he was already suffering from the loco-motor ataxia which killed him. The complexity of the subject matter, the manner in which it is composed, the sense of space and volume, the ingenuity of the perspective effects, recall *Music at the Tuileries,* but here there is an added richness, a magisterial certainty and richness of vision lacking in the earlier work.

The vibration of colour, the nature of light, the ability to capture at the moment anonymous figures, trapped between reality and its shadows – all these were Manet's constant concern, and he brought to their realization techniques which were very much his own. The light passages in his works were the dominant ones, brushed in with flowing, 'fat' paint; into this paint, while it was still wet, were worked the darks and the half-tones. In a way it almost simulated the fresco techniques of the early Italians, producing just that sense of limpid freshness which they share with Manet. He was the most revolutionary of traditionalists, the most traditional of revolutionaries.

The relationship between Manet and Berthe Morisot (1841–95) was close, and a good deal more complex than is often surmised. The great-granddaughter of Fragonard, she was born into an affluent banking

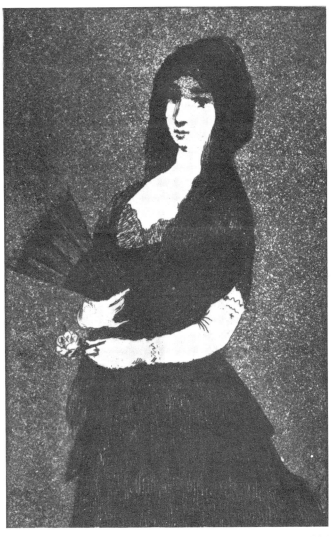

Edouard Manet. *Exotic Flower*, 1868. Etching, $6\frac{3}{8} \times 4\frac{1}{8}$ (16.2 × 10.4).

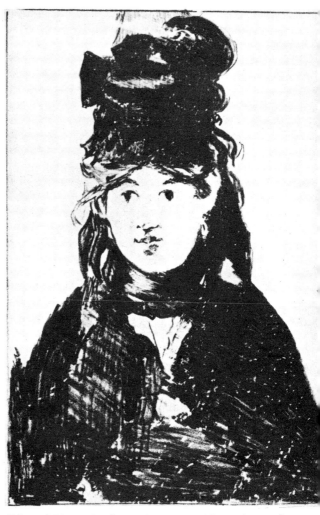

Edouard Manet. *Berthe Morisot*, 1872. Lithograph, $8 \times 5\frac{1}{2}$ (20.3×14).

family, and her mother created one of those cultural salons so typical of the Second Empire. Berthe Morisot began to study painting at the age of fifteen under Joseph-Benoît Guichard, and then under Corot, one of the habitués of her mother's salon. She worked with Corot until 1868, when she first met Manet, who had been very much taken by a painting, *Paris Seen from the Trocadéro* (Ryerson Collection, Chicago), which she had exhibited at the 1867 Salon. Not only did Manet praise its freshness and delicacy, its low-toned Whistlerian harmonies; he carried flattery to the point of imitation by using the theme and many of the compositional elements which it contained in the *View of the Paris World's Fair* (Nasjonalgalerie, Oslo) which he painted in the same year. It was inevitable that an artist with Morisot's particular sensibilities should have fallen under Manet's influence, and for several years she worked in his studio, as his pupil and his model (she eventually married his brother Eugène). His most famous portrait of her is in *The Balcony* (Louvre), of 1869, in which her dark, smouldering, almost Pre-Raphaelite, intensity provides a piquant foil to the pert attractiveness of the violinist Jenny Claus.

In the first Impressionist exhibition of 1874 Morisot
12 showed *The Cradle* (Louvre), in which the visual drama of the composition – with its strong counterpoint – emphasizes the delicacy of the paint and the lyricism of the subject matter, even though the main element, the baby, is technically unconvincing. A comparison with the portrait of her mother and younger sister Edna, painted some four years earlier (National Gallery of Art, Washington), shows how far she had moved towards a greater lightness, a keener sense of tonal recession, a crisp delicacy of touch. More consistently than any other of his students, she preserved Corot's silvery iridescence, and it was this quality, allied to an almost uninhibited and uncontrolled distribution of brush-strokes, which

created her personal style and explains the undoubted influence she was to have on Manet, exorcizing the darkness and chromatic inhibitions which character-
13 ized his work after the early 1870s. In her *In the Dining Room* (National Gallery of Art, Washington) of 1884, for instance, the strokes which make up the door of the cupboard, the maid's apron, the floor and the glass in the window are virtually free gestures, visual abstractions, through which shapes and forms emerge as from a mist.

Both as a person and as a painter Claude Monet (1840–1926) was very different from Manet. Less detached, less diffident, he was committed by his nature, by economic necessity – and by a kind of professionalism which, one feels, Manet would have disdained as being not quite *comme il faut* – to vigorous exploration of the substance and nature of his art. Perhaps this is what Zola meant: 'He's the only real man in a crowd of eunuchs' (though that remark, like so many things Zola said about art, was not really true, even though compelling). A provincial, born in Le Havre, with ferociously precocious talents, Monet eventually became more peripatetic than any of his colleagues, and his subject matter covers a remarkably wide range of places and themes. Boudin and Jongkind had been early influences on him, and though he deferred to Courbet, he did not imitate him. At the studio of Charles Gleyre he met Bazille, Renoir and Sisley, and he subsequently underwent the virtually obligatory experience of Fontainebleau. But though he had produced by this time some three hundred paintings, and had been accepted in the Salon, he was plagued by economic and psychological stress, and at the age of twenty-six tried to commit suicide (the psychological disturbance common to many of the Impressionists has not received the attention it perhaps merits).

It was not, however, until Monet came to London in 1870 that his art really jelled. Although he pro-

fessed to dislike Turner's 'exuberant romanticism', and denied in later life that Turner had any influence on him, it is impossible not to see in his use of aerial perspective, his treatment of wide reaches of landscape and of sea, even his concern with the transient, amorphous effects of fog, steam and clouds, something of the influence of the English landscape artists. Then there was the actual quality of London's light, which had so intrigued Whistler: mist on the Thames, with the great buildings and bridges swimming out of it; the green reaches of the parks; the constant mutations of atmosphere.

Pissarro explained it well some thirty years later in a letter to Wynford Dewhurst, who was writing a book, published in London in 1904, *Impressionist Painting*: 'Monet and I were very enthusiastic over London landscapes. Monet worked in the parks, whilst I, living at Lower Norwood, at that time a charming suburb, studied the effect of fog, snow and springtime. We worked from Nature, and later on in London Monet painted some superb studies of mist. We also visited the museums. The watercolours and paintings of Turner and Constable, the canvases of Old Crome, have certainly had an influence on us. We admired Gainsborough, Reynolds, Lawrence etc., but we were struck chiefly by the landscape painters, who shared more in our aim with regard to *plein air*, light, and fugitive effects. Watts and Rossetti strongly interested us among the modern men. About this time we had the idea of sending our studies to the Royal Academy. Naturally we were rejected' (pp. 31–32).

A visit to Holland, itself part-ancestor of the English tradition, confirmed Monet in his already obvious concern with light and transience, and some encouragement had come from the fact that Durand-Ruel bought his *On the Beach: Trouville*. A fruitful stay at Argenteuil brought him into closer contact with Manet and Renoir, confirming his instinctive belief

31

that Impressionism provided the appropriate framework for his creative intentions. To the exhibition of 1874, which owed a great deal to his initiative, he 14, 20 sent five paintings – including *Autumn at Argenteuil* and *Bridge at Argenteuil* – and seven pastel sketches. He continued his association with the movement until the fifth exhibition, to which he refused to send anything. In 1876 he began a series of paintings of the 15 Gare Saint-Lazare which, in their subject matter, their luminous treatment of the effects of atmosphere and steam, their lightly adumbrated but unifying structures, may well be thought of as the most 'typical' of all Impressionist paintings.

A steady, persistent worker, independent of the necessity of waiting on 'inspiration', agonizing over every picture he started, Monet found a prop for creativity in serialism, the creation of sets of works all using the same motif; and so virtually stumbled on one of his most original contributions to the language of contemporary art. Quite apart from the technical use of the system, which has been of such value to later painters, he proved and emphasized that a whole range of equally 'real' paintings could be made of the same subject, each varying according to the quality of the light and the time of day. At first rather haphazard – as in the *Gare Saint-Lazare* series, and the views of Westminster Bridge – they became more 16 purposeful with the *Poplar* series and that devoted to the façade of Rouen cathedral, culminating in the 21 *Nymphéas* series, the most remarkable attempt art had ever made to paint the passage of time.

Unlike Manet, he paid little attention to the old masters, being influenced rather by his contem- 19 poraries. In *Women in the Garden* (1866–67), and even more in later works, he evolved a method of depicting form by accumulating a mass of brush-strokes which are reconstructed and completed by the spectator to produce the effect he is suggesting. This again was a vital new element in art: the realization that the

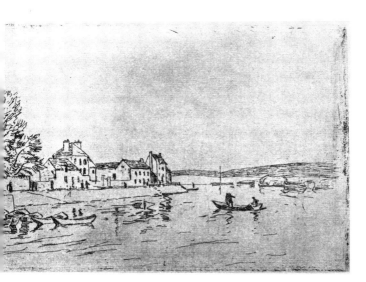

Alfred Sisley. *On the Banks of the Loing, Six Boats at their Moorings*, 1890. Etching, $5\frac{3}{4} \times 8\frac{3}{4}$ (14.7 × 22.4).

viewer has to participate, that he has to build his understanding of a painting, just as he 'reads' a landscape. This attitude was essential to the future of art. It was only because Monet destroyed the old limited, arbitrary concept of immutable form that the painters of the twentieth century were able to build new visual structures.

Of Alfred Sisley's contributions to the seventh Impressionist exhibition of 1882 Eugène Manet said that they were the most consistently coherent of the whole group, and it would be difficult to pick on a painter more typical of the movement as a whole. Born in Paris of wealthy English parents, Sisley's (1839–99) career was socially and economically almost the exact reverse of that of his colleagues. Encouraged to become a painter by his father, he began his career cushioned by affluence, and his

appearance at Gleyre's studio was that of a young dandy. Leaving there in 1863, at the same time as Bazille, Monet and Renoir, he worked with them, exploring the landscape of the forest of Fontainebleau and, like them, concerned himself with the shimmer of light on leaves and the analysis of shadow, painting, with similar fervour, the glades which had bewitched Daubigny and Courbet in the 1850s.

This was to be his familiar, beloved landscape; short visits to Brittany and England *(Molesey Weir)* were the only occasions when he left the Ile-de-France. Nor did he – unlike Renoir – go far beyond a dedication to landscape, nor yet, unlike Monet, concern himself with the transformations effected by time. The figures (as in the magical *Misty Morning*) are perfunctory. These limitations were self-imposed, but their rigour was probably reinforced by his lack of success. Although he succeeded in getting a painting into the Salon of 1866, Sisley was subsequently rejected, a situation compounded in difficulty by the economic ruin of his father as a consequence of the Franco-Prussian war. Poverty was to be his constant irritant; his outstanding virtue, modesty, he cultivated almost to the point of converting it into a vice. Yet he was singularly dedicated to achieving his own, admittedly limited, form of perfection, and his paintings, at their best, have a clarity, a brilliance and a sense of aesthetic honesty which are infinitely compelling. Nobody could better him in achieving the balance between form and the light which irradiates it, so that the one is never dissolved in the other. The transition between water, trees, building and cloud-flecked sky in *Floods at Port-Marly* is symptomatic of his consistent tonal mastery, and the way in which he conveys a sense of almost palpable atmosphere. Remarkable rather for the delicacy of his perception than for the dynamism of his imagination, Sisley frequently manifests a certain dullness of composition, as evinced for instance in the *Canal Saint-Martin,* where

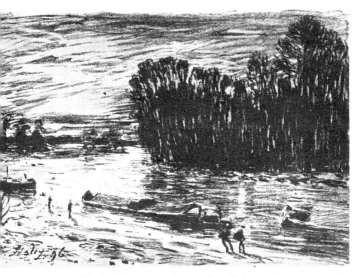

Alfred Sisley. *On the Banks of the Loing, Near Saint-Mammès*. Lithograph, $5\frac{3}{4} \times 8\frac{5}{8}$ (14.5 × 22).

the great weight of the barges grouped at the intersection of the horizontal and vertical extreme and mean ratios is mechanically balanced by the two masts accentuating the gap between the distant houses. But the treatment of the surfaces, the movement of the water, the radiance on the distant roof-tops, the texture of the canal wall are all rendered exquisitely. Sisley's was a kindred spirit to Corot's. The worst that can be said of him is that his pictorial reticence has been taken as a prototype by countless lesser talents, whose amateur enthusiasms have found in his paintings the justification for their own creative inanity.

Over the work of another member of the Gleyre quartet hangs the enigma of premature death. Frédéric Bazille (1841–70), arriving in Paris from Montpellier in 1861, was supposed to divide his time between studying medicine and studying art, but it

was the latter which obsessed him, and he became entirely committed to the emergent principles of Impressionism. With Monet and the rest he painted at Chailly in the forest of Fontainebleau, and also spent some time in that other habitat of young painters, the Norman coast. From a letter which he wrote to his parents at this time we can get some idea of the atmosphere of the time: 'As soon as we arrived at Honfleur we started to look for suitable landscape subjects. They were easy to find, for the country here is heaven. It would be impossible to find anywhere richer meadows or more beautiful trees. The sea – or rather the Seine, as it broadens out – provides a marvellous horizon to the masses of green. We are staying in Honfleur itself at a baker's, but we eat at a farm on the cliffs above the town, and it's there that we do our painting. I get up every morning at five, and paint all day till eight in the evening. However, you mustn't expect me to bring back a lot of good work. I'm making progress; that's all I want. I hope to be satisfied with myself after three or four years of painting. Soon I'll have to go back to Paris and apply myself to medicine, a thing which I abhor' (G. Poulain, *Bazille et ses amis,* Paris, 1932, p. 40). Progress he did make, despite some hesitancy (a weakness which always seems to affect artists whose economic circumstances absolve them from complete dependence on their work) and an inability to free himself from those Ingres-like conventions of academic precision which had characterized his training.

17-18 They are apparent in *The Family Reunion,* painted on the terrace of the Bazille home at Montpellier. But other things are also evident in this moving work: a clarity of vision, a simplicity of conception heightened by the bright, luminous colours, and a spontaneity, which are characteristic of youth. Three years after painting this picture, and shortly after his famous group portrait painted in his studio (the figure of himself in it was painted by Manet) had been rejected

by the Salon, he was killed in action at Beaune-la-Rolande.

Bazille had been a great help to his friends, providing not only admiration – even hero-worship – but also money. In 1869, when Monet was experiencing more than his usual difficulties, for instance, Bazille bought his *Women in the Garden* (Louvre) for the obviously philanthropic price of 2,500 francs. In both these respects his place in the group was taken by Gustave Caillebotte (1848–94), an engineer specializing in boat-building, who had met Monet at Argenteuil, where they were neighbours. A simple, intelligent, warm-hearted bachelor, Caillebotte was already an amateur painter, but the work of his new friends came to him with the force of a revelation, and by 1876 he was exhibiting at their group exhibitions. His talents were not enormous, but they were real, and though his portraits betray the influence of Degas, there was something very personal about his views of Paris and the villages of the Ile-de-France, and even more so about his paintings of working-class life and activities (*Workmen Planing a Floor,* Louvre).

But Caillebotte's importance cannot be estimated purely in terms of his work. He was above all a friend, *un bon copain,* helping to the utmost of his resources Monet, Renoir, Sisley and the rest, acting as an adviser and an organizer, and taking upon himself most of the responsibility for arranging at least three of the group exhibitions. At the age of 27 he made his will, naming Renoir as his executor and stipulating that enough money should be taken from his estate 'to arrange under the best possible conditions, an exhibition of the painters who are called *Les Intransigeants* or *Les Impressionistes*'. In the event this was not necessary, for by 1894 the Impressionists had secured a fair degree of recognition. And yet, although he left his collection of 65 paintings by the Impressionists to the State, it was only after three years of agitation that the authorities consented to accept 38,

and these did not enter the Louvre till 1928. It is typical of Caillebotte's nature that he always bought from his friends those paintings which they found most difficulty in disposing of, pictures which, of course, now are often recognized as their most important.

26 Camille Jacob Pissarro (1830–1903) was a movement in himself, and though he was by no means the greatest of the Impressionists, the movement as such owes more to him than to any other of its members. An able and coherent theorizer, a persistent stylistic explorer, a born teacher – his pupil Mary Cassatt said that he could have taught the stones to draw correctly – he was friend and counsellor to his associates; even the usually uncommunicative Cézanne once confessed, 'He was like a father to me. He was the sort of man you could consult about anything – a sort of God the Father.' He digested the discoveries of others; he expressed them in an understandable and engaging, but seldom very dramatic, style; he ensured the transmission of the Impressionist legacy to its inheritors; and Gauguin was to acknowledge, 'He was one of my masters, and I shall never deny the fact.' At those moments when the very existence of the group seemed threatened by the actual or imminent defection of members, Pissarro held it together; he contributed to all eight exhibitions, and accepted with equanimity the condescension, or even contempt, with which some of his contemporaries regarded him once they had tasted the fruits of success.

Born in the Virgin Islands, where his father, a Frenchman of Portuguese-Jewish descent, was a successful trader, he came to Paris in 1855, determined to become a painter. He admired Delacroix, took lessons from Corot, who was to be a major influence on his early work, and became a pupil at the Académie Suisse, an establishment opened by a former model, where students could draw and paint from the life without any formal tuition. There his work –

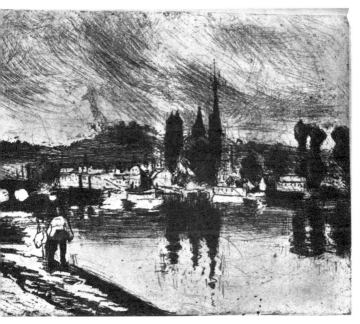

Camille Pissarro. *Cours La Reine, Rouen*, 1884. Etching, $4\frac{7}{8} \times 5\frac{1}{2}$ (12.2 × 13.9).

combining at this time something of Courbet's sense of compositional drama with the limpid luminosity of Corot – greatly impressed the young Monet. For the next two decades their careers were to be closely intertwined, and together they moved towards the techniques and attitudes of Impressionism. On the outbreak of war in 1870 they both moved to England, to which Pissarro was to return at regular intervals. They found London and its neighbourhood a rich source of subject matter, and, even more to the point, it was there that they met Durand-Ruel, who was to become the 'guardian angel' of Impressionism. As Pissarro once complained to Monet several years later, 'London has always attracted me, and yet I have

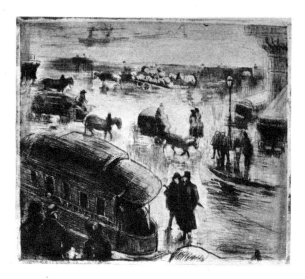

Camille Pissarro. *Place de la République, Rouen*, 1886.
Etching, $5\frac{3}{4} \times 6\frac{1}{2}$ (14.5 × 16.5).

27 never been able to make my London pictures well-liked.' It is hard to see why. The small *Lower Norwood, London, Snow Effect* of 1870 represents all that was best in Pissarro's work. Colour and form are perfectly harmonized, the recession into the upper reaches of the village street fits perfectly into the overall composition, without creating, as it might have done, a self-conscious hiatus; the leaden atmospheric effect is achieved without any ostentatious insistence.

On his return to Paris Pissarro discovered that most of the 1,500 canvases (this gives some idea of his output) left at his studio at Louveciennes had been destroyed, though one interesting survivor in the Louvre is the painting of that district which he must have painted shortly before leaving. Despite – or perhaps because of – near-poverty and despite failing eyesight, he painted with prodigious energy, torn

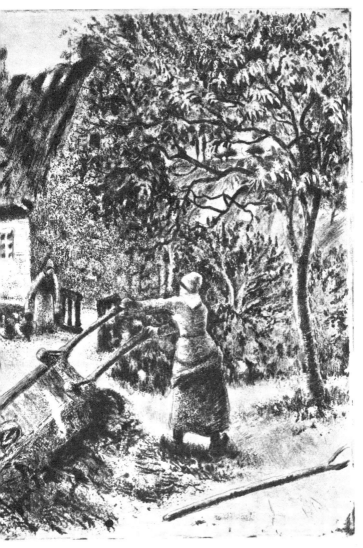

Camille Pissarro. *Woman Emptying a Wheelbarrow*, 1880.
Etching, $12\frac{1}{2} \times 9\frac{3}{4}$ (31.9 × 23.5).

often enough between what to him were the conflicting claims of mass and luminosity, sometimes close in feeling to Monet, sometimes inclining to the plastic preoccupations of Cézanne, and in doing so influencing both. By the 1880s, however, he was becoming increasingly aware of the structural problems which Impressionism seemed to sidetrack and, seduced by all the talk going on in studios about the theories of light and colour propounded by Rood, Helmholtz and Chevreul, he fell under the influence of Seurat with his belief in 'scientific' painting and his fond hope that he had discovered a technique for representing visual truth. For some five years Pissarro produced a series of Pointillist paintings based on the divisionist technique of tiny dots of pure colour, but he found this too rigid in the long run, and by 1890 had returned to his earlier style.

In 1892 he held a very successful one-man exhibition at Durand-Ruel's; he had found himself. He divided his time between Paris and Eragny, which had provided the subject matter for most of his Pointillist landscapes. In the city he concentrated mostly on fairly large urban views – such as the *Place du Théâtre Français* of 1898 – usually painted with an aerial perspective, in which he showed a remarkable ability to control complex subject matter, relate figures to their environment, maintain a sense of movement, and yet preserve a technical vivacity as convincing as that which informed the landscapes of his youth. Complementary to these, and usually painted in the country, were the landscapes, interiors, portraits and the like which expressed the *intimiste* side of his personality. In the 1880s he painted tender portraits of his son Félix, and of another son sitting with *The Little Country Maid*. A *catalogue raisonné* of his works, compiled in 1939 by his son Lucien, lists some 1,664 paintings, and when one adds to these those destroyed in 1870 it is possible to get some notion of his output.

29

28, 30

Probably today the most popular of all the Impressionists – though in fact he was by no means one of the most doctrinally committed – Pierre Auguste Renoir (1841–1919) displayed consistently in his works that sense of visual hedonism, that naturalness, that delight in spontaneous feeling which tend invariably to be associated with the movement. Devoid of dogmatic commitments, presenting himself as a creature of instinct, he once attributed to his generative organ the source of his creative powers. But this bit of braggadocio is balanced, if not explained, by a suggestion of melancholy, a certain appearance of anxiety which characterize the photographs and portraits of him which still exist.

The son of a tailor, Renoir made his first venture into art as a painter of flowers on porcelain, and it is difficult to disregard the theory that this influenced his subsequent development. Throughout most of his career his work possessed a decorative quality which allies him to those artists of the eighteenth century, such as Boucher, whose main activities were directed towards the provision of objects for the luxury trade. Indeed, the current prices paid for his works suggest that even today his appeal to the devotees of conspicuous expenditure is a powerful one.

While working in the studio of Gleyre Renoir came into contact with Monet, Bazille and Sisley, and by the late 1860s had started producing works which, though clearly influenced by both Courbet and Manet, still showed an intensely personal idiom. Many of these earlier works were street scenes, or interiors such as the very complex *Sisley and his Wife*. He was already concerned with the creative qualities of light, with the solidity of shapes and with the ambiguities of colour. But it was not until he spent some time with Monet at Bougival between 1867 and 1869 that he really began to experiment with these qualities in a free and dynamic way. His paintings of La Grenouillère, a popular bathing resort on the Seine, are

exercises in the representation of light, reflections and movements on water, expressed in rapid, freely applied brush-strokes.

Renoir always, however, had a nagging preoccupation with the human figure, and his concern was largely with employing in its interpretation that chromatic analysis and luminous transfiguration which could so much more easily be applied to landscape. That he achieved this transference was, in effect, his greatest personal contribution to Impressionism, and it was already becoming apparent in works such as the *Odalisque* which he exhibited at the Salon in 1870. Economic necessity impelled him to constant activity, and to any outlet, though after renting a studio in Montparnasse in 1872, where he produced more Parisian street scenes and landscapes of the Ile-de-France, he was taken up by Durand-Ruel. He was largely responsible for the hanging of the Impressionist exhibition of 1874, at which he 36 exhibited seven canvases, including *The Box,* one of his most brilliant transfigurations of the human presence, and *The Ballet Dancer.*

This exhibition was his major break-through, and during the next few years he produced some of his most memorable paintings, in which his own particular feeling for the play of light on people and objects was linked to a remarkable sureness of composition and feeling for the plastic qualities of the human form. Mostly he concerned himself with urban pleasures, with the life of the people, with the diffused Parisian gaiety of what future generations would remember wistfully (and perhaps inaccurately) as 33 *la belle époque.* Typical of this phase was *Moulin de la Galette,* which was exhibited at the third Impressionist exhibition in 1877. The glowing Chinese lanterns, the opalescent distances, the sense of vivacity seem to illuminate the canvas from within itself. But more remarkable even than the Watteauesque fervour of the handling is the way in which a vast and intricate

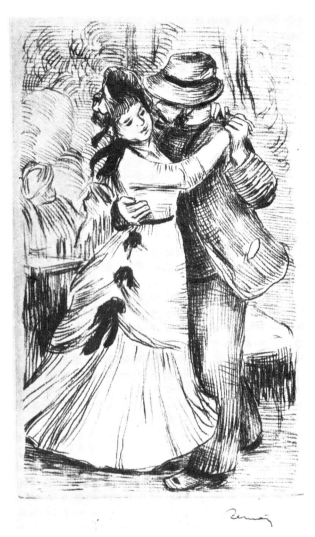

Auguste Renoir. *The Country Dance*, 1890. Etching, $8\frac{5}{8} \times 5\frac{1}{2}$ (22 × 14).

composition including scores of people (several of them were portraits of his friends, Frank-Lamy, Lhôte, Cordey and Rivière), and an infinity of poses and directions, has been welded, partly by light, partly by structure, into an ingeniously convincing unity.

But all the while Renoir's instincts were pulling him in a different direction. Above all else a professional, he was not uninterested in official recognition, and though this may not have been the determining factor in the change which started to take place in his art in the late 1870s, it must have had something to do with it; in any case it led him away from the group as such, and he only once again participated in one of their exhibitions, and that at the request of Durand-Ruel. It is significant that his portrait of Madame Charpentier and her daughters, painted in 1878, had a great success in the Salon of the following year. 'Renoir has had a big success at the Salon; I think he is now really launched, which is a good thing, as poverty is hard,' wrote Pissarro with his usual generosity. The simple triangular composition of the main figures, balanced by the table and chair at one corner, the prostrate dog at the other, bespeaks a more ordered spontaneity than had hitherto been apparent in his work, and these intimations of a new austerity are reinforced by a certain chromatic rigour.

In 1881 Renoir visited Algiers, and in the following year Italy, where he discovered in the works of Raphael intellectual precedents for continuing in the direction along which his painterly instincts led. Still using light as the unifying element in his paintings, he now began to prefer an Ingres-like definition of outline, a more static and overtly geometric form of composition, a less spontaneous brush-stroke, and a colder palette. At the same time, however – although by now he seemed to have become incapable of escaping from a stereotyping of faces – his conception

34-35

of the subjects which he painted was amazingly fresh and vivid. Nothing could display this more convincingly that the street scene in the National Gallery, London, entitled *The Umbrellas*. This work seems snapped, as it were, in a moment of time, full of delicious trepidations; and its elements of conscious contrivance, the blueish tonality, and the series of parallel lines which govern its composition, do nothing to impair its documentary vivacity. This is all the more remarkable in that a careful analysis of the painting shows that it was painted over a considerable period and was extensively recast. The two little girls and the lady behind them show strong indications of Renoir's earlier style, and are slightly out of harmony with the general feeling of the whole painting. Indeed, there is evidence of extensive retouching, and the portions of the canvas turned over the stretcher show that the original composition was a good deal larger (see Martin Davies, *National Gallery Catalogue: French School*, London, 1946, no. 3268), and contains elements of a girl's purplish skirt, a gloved hand and the lay-in of part of a face.

This painting seems to mark a withdrawal into a cerebral as opposed to a sensuous style (in Renaissance terms, a move away from Venetian towards Florentine affiliations). But this tendency was soon reversed – as if it had been his deliberate intention to *reculer pour mieux sauter* – and at the point at which he started to emerge from it he produced *The Large Bathers* (Philadelphia), which may be considered the last great exercise in the Renaissance tradition, tempered, nevertheless, by those perceptual sensibilities which the Impressionists were exploiting with such vigour.

Now gradually becoming more and more successful – and, as a consequence of this and the increasing felicity of his family life, more relaxed – Renoir was able to devote more attention to painting for pleasure. He had always tended to choose popular subjects, and by the late 1880s was concentrating more and more

on *intimiste* subjects – portraits of his wife and children, vases of flowers, the delights of domesticity, the diffused hedonism of the good life – and hinting
38 too – especially in the series of paintings of Gabrielle, a servant-girl who became an integral part of his iconography – at the pleasures of the bed as well as of the table and the fireside.

His *facture* became progressively looser, large surfaces of the canvas being dissolved in swirling maelstroms of iridescence, through which the forms emerge modelled in white highlights, silvery greys and coppery reds. Though he was to transfer much of his interest in volume to his sculpture, it never vanished in his paintings, where it always provided a centre of interest and point of visual reference. His
37 late works, like *Shepherd Boy,* glow constantly with an almost unbearable ruddiness; they seem on fire, and the whole of this last phase of his *oeuvre* is patient of many explanations. The two most obvious are that age and growing infirmity (he suffered from rheumatoid arthritis) weakened the control his hands could exercise over his brush, and that those changes in sight which come with senescence – and which influenced other great colourists such as Turner – impaired his chromatic sensibilities. There is also the fact that he spent more time in the South of France, painting in its sun-drenched roseate landscape. But whatever the cause, and however slight and evanescent some of these works may be – it is especially true of the landscapes, for this was a technique which did not lend itself to the adequate rendering of recession – their freedom, their 'coarseness', their dependence upon the gesture of the hand, help to explain how some see in them the antecedents of the Abstract Expressionism of the 1940s and 1950s.

To describe Degas and Cézanne as the mavericks of Impressionism is to give the movement a consistent aesthetic dogma which it never possessed. After all, Manet was its leader in spite of himself, and through-

42

out most of his career he was closer stylistically to Degas than to most of his colleagues who practised the more overt mannerisms which the movement was supposed to sanction. Cézanne, who according to one reading of art history finally destroyed Impressionism, exhibited at two of its group exhibitions (and would probably have liked to have done so at more); Degas, who was, according to the judgments of the time, a 'better' painter, exhibited at seven. They were in fact poles apart, and it was almost one of the accidents of history that they appeared to subscribe to a common allegiance.

Hilaire-Germain-Edgar Degas (1834–1917) was by instinct, by upbringing and by choice, a Baudelairean dandy, in his life as well as his art. Throughout his career his paintings, drawings and sculpture were marked by a kind of detached, almost masochistic, purity. He is the uninvolved spectator who describes young Spartans at exercise (National Gallery, London, 1860) and a bored, disillusioned couple sitting moodily over their absinthe (Louvre, 1876) with the same dispassionate eye. The subjects, of course, are widely different: the one looks back to David, the other forward to Toulouse-Lautrec. The styles are dissimilar: the one has the clear outlines of a Florentine painting, the other the free, spontaneous handling of one who has experienced, even though he has not been swept away by, the discoveries of Impressionism. But both are cool, in our contemporary sense.

Like Berthe Morisot the member of a banking family, Degas started off at the Ecole des Beaux-Arts, and had an early and rewarding experience of Italy, where he made meticulous copies of works by Leonardo, Pontormo and others. It was during this time that he acquired his remarkable gifts as a draughtsman in the classic tradition, gifts which were to characterize all his later work and were the sources of his greatness and of his weakness. It is an interesting comment on his attitude towards the art of his time

that he saw nothing inconsistent in exhibiting one of the major products of this period of his development, the young Spartans (the National Gallery title, *Young Spartans Exercising,* is a little coy; Degas called it *Petites filles spartiates provoquant des garçons*), at the Fifth Impressionist Exhibition in 1880. Appropriately enough he met Manet while copying a Velázquez in the Louvre. They became close friends, artistic allies. Degas went in the following year for a short visit to 42 the United States, where he painted *The Cotton Exchange in New Orleans* (Musée des Beaux-Arts, Pau) which embodied the qualities his painting had acquired at the moment when he made contact with Impressionism. Many of them already exemplified characteristics which the group was already elevating into doctrines: the sense of actuality; the social realism of the subject matter; the instaneity of the moment at which the brokers are 'snapped' (the camera was to have a more definitive influence on Degas than on any other of the group); the sharpness of the underlying draughtsmanship; the way in which an apparently haphazard grouping of figures masks a sophisticated and ingenious composition. The painterly technique is still basically traditional, close in fact to the early Manet, but under no circumstances could this have been mistaken for an 'academic' painting.

The perspective angle is unusual, and emphasizes the compositional motif of the diagonal wedge of figures which vanishes away into the distant corner of the room. This delight in the difficult was always to remain one of the main characteristics of Degas's work. An even more impressive example, of the same 39 period, is *At the Races* (Louvre), painted between 1869 and 1872; here the angle from which he sees the horses, the course and the stand involves such technical expertise that one is immediately reminded of those Renaissance masters such as Uccello and Mantegna, who also set themselves perspectival

problems of dazzling complexity. In this work another of his favourite devices is apparent – the pushing to the edges of the canvas of large sections of the composition, so that they are occasionally cut off, as in a photograph, and the spectator's imagination becomes engaged in visualizing their continuance into his own spatial ambiance. Degas canonized the casual, conferring on the moment of observation a sense of perpetuity which it had never known in art before. At the same time he was the greatest portraitist that the movement produced. Renoir, for instance, was a facial mannerist who made everybody look vaguely alike. Perhaps this effect arose because portraits demand a certain structural emphasis if they are to be anything more than a pretext for the exercise of certain painterly preoccupations – the sitter being no more intrinsic to the totality of the painting than an apple to Cézanne, or a guitar to a Cubist. But Degas was a living camera, noting and recording, sometimes with insouciance, sometimes with tenderness, as in the *Head of a Young Woman* (Louvre, 1867), sometimes with deep psychological insight.

Linda Nochlin has suggested this (*Realism,* London, 1971, p. 198) most convincingly in relation to *The Bellelli Family* of 1858–62: 'While Bazille, in his representation of the upper middle class, has firmly rejected the aura of sentimentality or nostalgia that sometimes seems inherent in the theme of the family, transforming his subject into a motif modern in both emotional tone and pictorial structure, Degas has gone one step further, making his family portrait *The Bellelli Family* an occasion for the dispassionate and objective recording of subtle psychological tensions and internal divisions in the representation of a refined group from the Italian minor aristocracy. Once again the implications are built into the pictorial structure; there is no meaningful anecdote to serve as the 'purpose' of the picture as there is in most contemporary English work representing a family of

a similar class in a situation of overt external and internal disruption.'

Few artists have had a keener sense of pictorial structure than Degas. The spontaneity of his works is an illusion – albeit an infinitely satisfying one. Their compositional logic is absolute, and his treatment of reality is always subordinate to the need for total representation. It was here that he parted most decisively from Impressionism, and most clearly showed himself to be a classicist working within a romantic framework. To the first Impressionist 45-46 exhibition he sent ten paintings, including *The Dance Foyer* (Louvre), and continued to show at all the subsequent exhibitions. Impressionism had contributed much to his technical armoury. He had come to it as one dependent, in the tradition of Ingres, on a linear perfection which had been hammered out in his drawing sketchbooks. It gave him a new sense of the value of light as a means of adding volume, vibration and the suggestion of a dimension more profound than that provided by traditional perspective. His paint was always thin; it never had the crusty quality which characterized the technique of Monet or Pissarro. His forms were never dissolved in light; they were accentuated and moulded by it.

Apart from portraiture, the subject matter of Degas's work is of considerable interest and significance. The early classical themes were succeeded by a series devoted to race-courses, ballet, opera, theatre 44 *(The Rehearsal)* – the favourite relaxations of polite society, as opposed, for instance, to the more plebeian entertainments which Renoir chose to depict. In the 1880s, however – at a period when he was increasingly coming to rely on pastel as a medium to provide just those elements of spontaneity and vibrancy which he so relished – Degas turned his attention to the intimacies of womanhood, with an almost revengeful acuity of observation, delighting in the most apparently graceless poses and undignified actions. But,

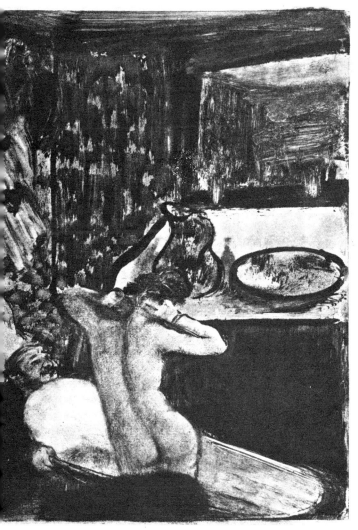

Edgar Degas. *Admiration, c.* 1880. Monotype, ink on paper,
$8\frac{1}{2} \times 6\frac{3}{8}$ (21.5 × 16.1).

unlike the boudoir paintings of the previous century, they were entirely without salacity, and they were the harbingers of one of the dominant themes of late nineteenth-century art. They were inspired partly by that late Romantic fascination with the sordid – the *nostalgie de la boue* – which Baudelaire had first brought out into the open; but to a much greater extent they were a by-product of attitudes which characterized the whole Impressionist ideology. They were sincere, they were real, and above all else they were totally alien to anything artists had done before, so that they could be approached by eyes innocent of accepted conventions. They had no precedents and were therefore endowed with a visual honesty which had become indispensable to living art: a work such as
47 *Woman Combing her Hair* is a genuinely fresh departure.

Another recruit to Impressionism from the world of banking was Mary Cassatt (1845–1926) who was born in Pittsburgh, of French descent. Trained at the Pennsylvania Academy of the Fine Arts in Philadelphia, she came to Europe when she was twenty-one and imposed on herself the same rigorous study of the masters of drawing – especially Correggio and Ingres – which Degas had undergone. Perhaps this is why he was so impressed by one of her paintings at the Salon of 1874, and from that moment a close bond was established between them. Although she was never actually his pupil, her work was influenced by his in very much the same way that Berthe Morisot's was by Manet. But Mary Cassatt had an individuality of
48 her own, cultivating intimate domestic themes with a sensitivity and charm which allow one to accept the analogies drawn between her and Henry James. She came into her own as a maker of prints – a medium with which most of the Impressionists, especially Degas and Pissarro, toyed at one time or another – being especially successful with soft-ground etching, and showing very clear evidence of the influence

which Japanese art exerted on her. Of some importance was the extent to which she was responsible for transmitting Impressionism to the United States, thereby not only opening up a new and avid market, but also influencing the work of painters such as Theodore Robinson, Ernest Lawson and Arthur Clifton Goodwin.

Paul Cézanne, like Degas, reacted significantly to and against Impressionism; and there was something complementary in their reactions. Whereas the one turned to linear structuralism, extended and diffused by the interplay of light and shade, the other introduced into his work a light which is reinforced by chromatic masses and itself enhances them. Both were concerned with new concepts of space, which were eventually to revolutionize European art, but Cézanne went a good deal further in this direction than Degas by controlling perspective in several directions, and so opening up an entirely new synthesis of visual expression. As he himself once said, 'I shall always be the primitive of the path I discovered.'

Cézanne (1839–1906) was born and died in Aix-en-Provence (he was another Impressionist from a banking family) and had the advantage of having Zola for a schoolfellow. In 1861 he persuaded his family to let him come to Paris, where he worked intermittently for a while at the Académie Suisse, but there he was discontented, aggressive, moody, finding little to admire either in the work of his contemporaries or in his own. He had a passion for violent, erotic painting, in muddy colours, which owed more to Delacroix than anyone else, though there were suggestions of the influence of Courbet. He seemed constantly at this time to oscillate between strangely adolescent dreams – A Modern Olympia of 1870, which could be seen either as a snide comment on Manet or as a sexual fantasy, is typical – and half-hearted essays in direct observation. It was not that he was out of contact. In the course of his intermittent visits to

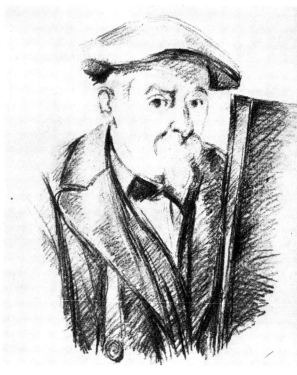

Paul Cézanne. *Cézanne in Beret, Before an Easel*. Lithograph, $13 \times 11\frac{1}{8}$ (33×29).

Paris he haunted the Café Guerbois. He had had work in the Salon des Refusés, and submitted regularly, but unsuccessfully, to the Salon. He picked up ideas from the Impressionists, but his adherence to them sprang rather from a generalized feeling of revolt against the system, than from any deep feeling of allegiance.

When he was thirty-three, however, a change took place which may well be connected with the fact that he achieved a large degree of emotional security through the stabilization of his relationship with

Marie-Hortense Fiquet, a young model, who bore him a son in that year. Of more immediate relevance was his settling for two years in Auvers-sur-Oise, where he worked with Pissarro. This was precisely the kind of experience he needed. Instead of the confused and sometimes contradictory titbits of doctrine and theory which he had picked up from the cafés of Paris, he was presented, in a suitable environment, with the practical demonstrations of an artist who not only knew what Impressionism was about, but had reduced it to a coherent, transmissible formula. The effect on Cézanne was immediate. He began to observe directly from nature; he began to achieve that optical fusion of tones which was one of the emancipating discoveries of the movement. His palette lightened, and though his paintings were never to reach out for that documentary quality which Pissarro, Monet, Renoir and Degas often achieved, they were to be free from their earlier iconography of violence.

During the next four years his relationship with official Impressionism (if the phrase is not self-contradictory) was to be close, and he exhibited at the exhibitions of 1874 and 1877. To the former he con-
51 tributed three works including *Man with Straw Hat,* in which he realized his objective of an almost palpable solidity of form, achieved through compositional simplicity, the colour reinforcing and complementing the unity of the painting rather than being a mere gloss on its form. Whereas with most other Impressionists the forms seem to swim towards the spectator through a mist of light, with Cézanne, even at this stage, the light seems to emerge from the forms; and, when he said 'Light devours form; it eats up colour', it was almost a complaint. In a way, because of a certain technical ineptitude which he had to struggle to overcome, he possessed that sense of innocence when confronted with his subject matter which a painter like Degas could only achieve by the most complicated means. What Cézanne always represented

was his own personal reaction to what he saw – a kind of psychological realism.

But all the time something else was fretting him: the oft-repeated desire to create a synthesis of Renaissance discipline and Impressionist truth – to 'redo Poussin after nature', and 'make Impressionism something solid and durable like the Old Masters'. What he really wanted was to organize into a solid structural role all those visual elements which could be rendered truthfully only by Impressionist techniques. A lot of nonsense has been written on this score, and Clement Greenberg's warning is especially relevant: 'The Impressionists, as consistent in their naturalism as they knew how to be, had let nature dictate the over-all design and unity of the picture, along with its component parts, refusing in theory to interfere consciously with their optical impressions. For all that, their pictures did not lack structure; insofar as any single Impressionist picture was successful it achieved an appropriate and satisfying unity, as must any successful work of art. (The overestimation by Roger Fry and others of Cézanne's success in doing exactly what he said he wanted to do is responsible for the cant about the Impressionists' lack of structure; in its stead the Impressionists achieved structure by the accentuation and modulation of points and areas of colour and value, a kind of 'composition' which is not inherently inferior to or less 'structural' than the other kind.) Committed though he was to the motif in nature in all its givenness, Cézanne still felt that it could not of its own accord provide a sufficient basis for pictorial unity; what he wanted had to be more emphatic, more tangible in its articulation and therefore, supposedly, more 'permanent'. And it had to be *read* into nature' (*Art and Culture*, London, 1973, p. 51).

The changes which his art underwent during the next twenty years, and which were to link the world of the Impressionists with the world of Braque, Léger

and Ozenfant, were all motivated by his passionate desire to create a new classical syntax with the vocabulary of Impressionism. Sometimes external factors intervened – especially in regard to his landscapes. The change of locale from the small cosy villages of Pontoise to the larger, exaggerated reaches of the South, with its strong all-pervasive light, its great distances apparent to the eye, its chequered fields and intersected mountains, pushed him even farther into a more ruthless investigation of the mechanics of composition than any of his contemporaries had undertaken. He followed two different approaches, which coincide exactly with those Cubism was to use in the first two decades of the twentieth century. In paintings such as *Chestnut Trees at the Jas de Bouffan* (1883) or the *Mont Sainte-Victoire* of the same year, a process of synthesis is adopted: large and small cubes of form and colour are massed together to create the image. In others – and here again the persistent preoccupation with Mont Sainte-Victoire serves as a touchstone – an analytical approach predominates: forms are extracted from what is seen, volume is dissociated at certain dramatic points around which a new structure is formed. The whole canvas is in movement as the tesserae of paint flicker between their surface impression and the image they create. In all his landscapes the sense of space is emotive rather than descriptive, so that at the great distances at which he sometimes paints Mont Sainte-Victoire, one can sense, though one cannot see, the intervening areas.

The organization of volumes around a culminating point is very evident in Cézanne's portraits too, such as that of Chocquet (1877), where each part of the sitter is divided into units of coloured volumes which are put together to create the totality of the image. Later, however, especially in the series of *Card Players,* he seemed almost to extend his volumetric passion to Euclidian proportions: each part of each figure is

expressed in terms of cylinders or cubes, but the process is never pushed to its logical limits, and the pleats in the clothes, the pipes, the faces, the background have a Courbet-like lusciousness which counteracts the stringency of the modelling. 'If you paint you can't help drawing as you do it', he once said to Emile Bernard, and it is difficult at times not to feel that the whole of his creative outlook was orientated to the still-life, a world which lent itself perfectly to displaying that solidity, that rotundity which so enraptured him. His fruit has the eternal quality of the vegetation in a seventeenth-century nature poem by Herrick or Traherne; but this is because his paintings are autonomous objects, and the elements which constitute them are valid for no reason other than that they are in them. The apples and oranges are the painting; the painting is the apples and oranges.

It was Cézanne more than anybody else who transmuted Impressionism into a mode of vision and a technique which would reach far beyond the limits of the nineteenth century, a fact which has led to a good deal of near-hysterical and certainly uncritical adulation, for, ironically enough, his art has also spawned a vast amount of flaccid academicism quite alien to his own ideas.

Monet neatly summed up the later development of Impressionism in 1880 when he said that what had once been a church was now a school, and as a school it spread rapidly, becoming, in each country it reached, first a suspect revolutionary art form, and then after a few decades a moribund official idiom. And in all cases it was the earliest protagonists of the style who were the most vital. In Germany Max Liebermann (1847–1935) and Max Slevogt (1868–1932); in what is now Yugoslavia Ivan Grohar (1867–1911) and Matej Sternen (1870–1949) were typical of a generation which adapted Impressionist techniques and attitudes to a national style. Whole groups grew

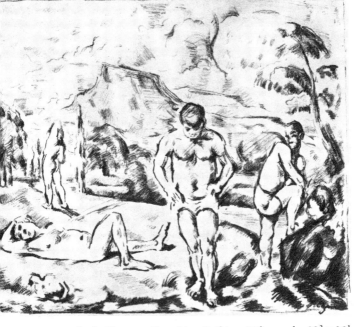

Paul Cézanne. *Four Men Bathing*. Lithograph, $19\frac{3}{8} \times 16\frac{1}{8}$ (50×41).

up – in Amsterdam, for instance – dedicated to the propagation of the new gospel. With England the links had always been close: there were the influence of Whistler who had been marginally connected with the movement, the writings of George Moore and above all else the fact that from 1865 till 1892 Alphonse Legros – who although not himself an Impressionist, had been a friend of Manet, and in close contact with the influences which created the movement – taught first at what is now the Royal College, and then at the Slade. It was the latter institution which spawned the New English Art Club, whose leaders, Steer, Tonks, Orpen, McEvoy and John, were all indebted to

Impressionism for that liberating impulse which is
60 seen at its most persuasive in Steer's *Girls Running, Walberswick Pier*.

Impressionism in fact had revolutionized art, and indeed the word was used, admittedly rather loosely, to describe literary and musical movements. But it was its developers rather than its imitators who were most vital, and Cézanne was not alone. In 1884 there was founded in Paris a *Société des artistes indépendants*, most of whose members were self-consciously dedicated to renovating Impressionism by adding to it the systematic qualities which they thought it lacked. They set out to provide a doctrinal framework for future developments which would give light a structure based on small points of pure colour, applied in such a way as to fuse when perceived by the beholder. The outstanding figure of Pointillism was Georges Seurat (1859–91) who had, significantly, studied under Henri Lehmann, the pupil of Ingres. Always intent on returning to those schemata which orthodox Impressionism had set out to destroy, he even went on in the later stages of his career to attempt to devise modes for expressing emotion and feeling, very much in the same way as the Carracci had some centuries earlier. His subject matter was
58 resolutely in the Impressionist tradition – landscapes
59 and popular entertainment – and his paintings radiate a lyricism which has little apparent connection with the austere aesthetic ideology they are supposed to exemplify.

It was inevitable that so beguiling a doctrine should attract disciples; in France Seurat's ideas were
61 followed by artists such as Paul Signac (1863–1935) Henri-Edmond Cross (1856–1910) and Maximilien Luce (1858–1941); outside France it was especially effective in Belgium, where through Theo van Rysselberghe (1862–1926) and Henri van de Velde (1863–1957) it not only created a new group, 'The Society of Twenty', but also contributed a great deal of

stamina and inspiration to the rather eclectic manifestations of Art Nouveau. In Italy too, where Impressionism itself had had little effect, it was enthusiastically received, though given a literary and naturalistic colouring, in the works of Giovanni Segantini (1859–99) and Gaetano Previati (1852–1920), who transmitted its attitudes to the Futurists, on whose shimmering technique it clearly had a determining influence.

Neo-Impressionism is clearly the ancestor of most subsequent hard-edge art from Braque to Stella, and in this sense it represents one of the dominant voices in the current dialogue of painting. But the other, the 'soft', also stemmed from Impressionism. The importance of creative sincerity, the ability to express emotional reactions freely, to surrender to the instinct of the hand, and a realization of the emotive as well as the descriptive and analytical use of colour – all these are qualities which led through Van Gogh, on whom the works of the Impressionists had a liberating and crucial effect, to the Fauves and on to the Abstract Expressionists. Impressionism set painting on a new path, and virtually everything which has happened since can be related to it.

62

Chronology

1863 Salon des Refusés includes works by Manet, Cézanne, Jongkind, Whistler, Pissarro. Delacroix dies.

1864 Monet, Renoir, Cézanne, Sisley and Bazille work as a group at Chailly.

1865 Manet exhibits his *Olympia*, which is the target of violent criticism.

1867 Paris World Fair has sections devoted to works by Manet and Courbet. Zola writes about Manet's works.

1869 Manet exhibits *Déjeuner sur l'herbe* at Salon.

1870 Outbreak of Franco-Prussian War. Monet and Pissarro come to England.

1872 Durand-Ruel exhibits Impressionist paintings in London.

1873 Second Salon des Refusés.

1874 15 April–15 May. First Impressionist exhibition at Nadar's, 35 boulevard des Capucines, with 30 participants.

1875 A group of Impressionists organize an auction sale at Hôtel Drouot; average price 144 francs.

1876 Second Impressionist exhibition, 11 rue le Peletier, with eighteen participants, who begin to meet together at the Café de la Nouvelle-Athènes.

1878 Paris World Fair; Duret publishes *Les Impressionistes*.

1879 Fourth Impressionist exhibition, 28 avenue de l'Opéra, with fifteen participants. Manet exhibits the *Execution of Maximilian* in New York.

1880 Fifth Impressionist exhibition, 10 rue des Pyramides, with eighteen participants.

1881 ˙Sixth Impressionist exhibition, 35 boulevard des · Capucines, with thirteen participants.

1882 Durand-Ruel organizes seventh Impressionist exhibition, and arranges showings of their work in London, Berlin and Rotterdam. Important exhibition of Japanese prints at the gallery of Georges Petit.

1883 Manet dies.

1884 Successful memorial exhibition of Manet's works. Salon des Indépendants started.

1886 Eighth and last Impressionist exhibition at 1 rue Lafitte, with seventeen participants. Zola publishes *L'Œuvre*, based on his relationship with Cézanne, and Van Gogh arrives in Paris. Durand-Ruel holds exhibition of Impressionists in New York.

1889 Monet and Rodin exhibit at Georges Petit's.
1890 Death of Van Gogh.
1891 Death of Jongkind, Seurat.
1892 Pissarro holds retrospective exhibition at Durand-Ruel's.
1895 Death of Berthe Morisot.
1899 Death of Sisley.
1903 Death of Pissarro.
1906 Death of Cézanne.
1917 Death of Degas.
1919 Death of Renoir.
1926 Death of Monet.
1927 Death of Guillaumin.

Further Reading

Probably more books have been written about Impressionism, and about the artists involved, than on any other subject in art history, apart from the Renaissance. Still by far the best, and itself containing a good bibliography is John Rewald, *The History of Impressionism,* New York, 1946; second edition, 1961. Of almost equal value, and in some ways more useful in that it examines critical attitudes towards Impressionism in some depth, and overall is more up to date is the entry in *The Encyclopaedia of World Art,* New York, 1967. Earlier in date, but of great documentary value is Lionello Venturi, *Les Archives de l'impressionnisme,* Paris, 1939, (2 vols.).

Other important general treatments are: Raymond Cogniat, *Au temps des Impressionnistes,* Paris, 1950 (English translation, New York, 1951); Jean Leymarie, *L'Impressionnisme,* Geneva, 1955 (English translation, Geneva, 1955). Two interesting examples of shorter treatments are William Gaunt, *The Impressionists,* London and New York, 1972, Basil Taylor, *The Impressionists and their world,* London, 1953.

There is in fact a wealth of documentary material, consisting especially of various editions of the letters and other writings of most of the main protagonists, those of Berthe Morisot, Pissarro, Bazille, Degas, J. E. Blanche being of particular interest.

A great deal of valuable and stimulating information is available in a number of peripheral books, among which

the following may be cited: A. Boime, *The Academy and French Painting in the Nineteenth Century*, London, 1971; T. J. Clark, *Image of the People*, London and Greenwich, Conn., 1973; M. Easton, *Artists and Writers in Paris: 1803–1867*, London, 1964; U. Finke (ed.), *French Nineteenth-Century Painting and Literature*, Manchester, 1972; A. Scharf, *Art and Photography*, London, 1968; L. Nochlin, *Realism*, London and New York, 1971.

List of Illustrations

Measurements are given in inches and centimetres, height first.

12 Berthe Morisot (1841–95). *The Cradle,* 1873. Oil on canvas, 22 × 18⅛ (56 × 46). Louvre, Paris. See p. 23.

13 Berthe Morisot (1841–95). *In the Dining-room,* 1886. Oil on canvas, 24¼ × 19¾ (61.6 × 50.2). National Gallery of Art, Washington, Chester Dale Collection. See p. 24.

14 Claude Monet (1840–1926). *Autumn at Argenteuil,* 1873. Oil on canvas, 22 × 29½ (56 × 75). Courtauld Institute Galleries, University of London. See p. 25.

15 Claude Monet (1840–1926). *Gare Saint-Lazare,* 1877. Oil on canvas, 29½ × 39½ (75 × 100). Louvre, Paris. See p. 26.

16 Claude Monet (1840–1926). *Poplars on the Epte,* 1891. Oil on canvas, 39½ × 25¾ (101 × 66). Philadelphia Museum of Art. See p. 26.

17–18 Frédéric Bazille (1841–70). *Family Reunion,* 1876. Oil on canvas, 59⅞ × 90½ (152 × 230). Louvre, Paris. See p. 30.

19 Claude Monet (1840–1926). *Women in the Garden,* 1866–67. Oil on canvas, 100½ × 80¾ (255 × 205). Louvre, Paris. See p. 26.

20 Claude Monet (1840–1926). *The Bridge at Argenteuil,* 1874. Oil on canvas, 23½ × 31½ (60 × 80). Louvre, Paris. See p. 25.

21 Claude Monet (1840–1926). *Water-lilies: Sunset* (detail), 1914–18. Oil on panel, 77½ × 234 (197 × 594). Musée de l'Orangerie, Paris. See p. 26.

22 Alfred Sisley (1839–99). *Molesey Weir, Hampton Court, c.* 1874. Oil on canvas, 20¼ × 27 (51 × 69). National Gallery of Scotland, Edinburgh. See p. 28.

23 Alfred Sisley (1839–99). *Floods at Port-Marly,* 1876. Oil on canvas, 23⅝ × 32 (60 × 81). Louvre, Paris. See p. 28.

24 Alfred Sisley (1839–99). *Canal Saint-Martin, Paris,* 1870. Oil on canvas, 19⅝ × 25⅝ (50 × 65). Louvre, Paris. See p. 28.

25 Alfred Sisley (1839–99). *Misty Morning,* 1874. Oil on canvas, 19⅝ × 24 (50 × 61). Louvre, Paris. See p. 28.

26 Camille Pissarro (1830–1903). *Self-portrait,* 1873. Oil on canvas, $22 \times 18\frac{3}{8}$ (56 × 46.7). Louvre, Paris. See p. 32.

27 Camille Pissarro (1830–1903). *Portrait of Félix,* 1883. Oil on canvas, $21\frac{3}{4} \times 18\frac{1}{4}$ (55.3 × 46.3). Tate Gallery, London. See p. 36.

28 Camille Pissarro (1830–1903). *Lower Norwood, London,* 1870. Oil on canvas, $13\frac{3}{4} \times 18\frac{1}{4}$ (35 × 41). Trustees of the National Gallery, London. See p. 34.

29 Camille Pissarro (1830–1903). *Place du Théâtre Français,* 1898. Oil on canvas, $28\frac{1}{2} \times 36\frac{1}{2}$ (72.5 × 93). County Museum of Art, Los Angeles. Collection Mr and Mrs G. Gard de Sylva. See p. 36.

30 Camille Pissarro (1830–1903). *The Little Country Maid,* 1882. Oil on canvas, $25 \times 20\frac{7}{8}$ (63.5 × 53). Tate Gallery, London. See p. 36.

31 Claude Monet (1840–1926). *On the Beach, Trouville,* 1870. Oil on canvas, 15×18 (38 × 46). Trustees of the National Gallery, London. See p. 25.

32 Auguste Renoir (1841–1919). *The Umbrellas, c.* 1884. Oil on canvas, $71 \times 45\frac{1}{4}$ (180 × 115). Trustees of the National Gallery, London. See p. 41.

33 Auguste Renoir (1841–1919). *Moulin de la Galette,* 1876. Oil on canvas, $51\frac{5}{8} \times 68\frac{7}{8}$ (131 × 175). Louvre, Paris. See p. 38.

34–35 Auguste Renoir (1841–1919). *Madame Charpentier and her Children,* 1876. Oil on canvas, $60\frac{1}{2} \times 74\frac{7}{8}$ (153.6 × 190.2). Metropolitan Museum of Art, New York. See p. 40.

36 Auguste Renoir (1841–1919). *The Box,* 1874. Oil on canvas, $31\frac{1}{2} \times 23\frac{5}{8}$ (80 × 64). Courtauld Institute Galleries, University of London. See p. 38.

37 Auguste Renoir (1841–1919). *Shepherd Boy,* 1911. Oil on canvas, $29\frac{1}{2} \times 36\frac{1}{2}$ (75 × 92.7). Museum of the Rhode Island School of Design, Providence. See p. 42.

38 Auguste Renoir (1841–1919). *Gabrielle with Roses,* 1911. Oil on canvas, $21\frac{7}{8} \times 18\frac{1}{2}$ (55.5 × 47). Louvre, Paris. See p. 42.

39 Edgar Degas (1834–1917). *At the Races,* 1869–72. Spirit medium on canvas, $18\frac{1}{8} \times 24$ (46 × 61). Louvre, Paris. See p. 44.

40 Edgar Degas (1834–1917). *Head of a Young Woman,* 1867. Oil on canvas, $10\frac{5}{8} \times 8\frac{5}{8}$ (27 × 21.9). Louvre, Paris. See p. 45.

41 Edgar Degas (1834–1917). *The Bellelli Family,* 1860–62. Oil on canvas, $78\frac{3}{4} \times 98\frac{1}{2}$ (200 × 250). Louvre, Paris. See p. 45.

42 Edgar Degas (1834–1917). *The Cotton Exchange in New Orleans,* 1873. Oil on canvas, $29\frac{1}{8} \times 36\frac{1}{4}$ (74 × 92.1). Musée des Beaux-Arts, Pau. See p. 44.

43 Edgar Degas (1834–1917). *Absinthe,* 1876. Oil on canvas, $36\frac{1}{4} \times 26\frac{3}{4}$ (92 × 68). Louvre, Paris. See p. 45.

44 Edgar Degas (1834–1917). *The Rehearsal, c.* 1877. Oil on canvas, $26 \times 39\frac{3}{8}$ (66 × 100). Glasgow Art Gallery, Scotland (Sir William Burrell Collection). See p. 46.

45–46 Edgar Degas (1834–1917). *The Dance Foyer at the Opera,* 1872. Oil on canvas, $12\frac{1}{2} \times 18$ (32 × 46). Louvre, Paris. See p. 46.

47 Edgard Degas (1834–1917). *Woman Combing her Hair, c.* 1887–90. Pastel, $32\frac{1}{4} \times 22\frac{1}{2}$ (82 × 57). Louvre, Paris. See pp. 46–48.

48 Mary Cassatt (1845–1926). *Girl Arranging her Hair,* 1886. Oil on canvas, $29\frac{1}{2} \times 24\frac{1}{2}$ (75 × 62). National Gallery of Art, Washington, Chester Dale Collection.

49 Paul Cézanne (1839–1906). *The Man with a Straw Hat,* 1870–71. Oil on canvas, $21\frac{5}{8} \times 15\frac{3}{8}$ (54.9 × 39). Metropolitan Museum of Art, New York. See p. 51.

50 Paul Cézanne (1839–1906). *Portrait of Chocquet,* 1875–77. Oil on canvas, $18\frac{1}{8} \times 14$ (46 × 36). Private Collection. See p. 53.

51 Paul Cézanne (1839–1906). *Mont Sainte-Victoire,* 1885–87. Oil on canvas, $26 \times 35\frac{3}{8}$ (66 × 90). Courtauld Institute Galleries, University of London. See p. 53.

52 Paul Cézanne (1839–1906). *Chestnut Trees at the Jas de Bouffon,* 1885–87. Oil on canvas, $28\frac{3}{4} \times 36\frac{1}{4}$ (73 × 92). Minneapolis Institute of Arts. See p. 53.

53 Paul Cézanne (1839–1906). *Quarry and Mont Sainte-Victoire,* 1898–1900. Oil on canvas, $25\frac{5}{8} \times 31\frac{7}{8}$ (65 × 81). Baltimore Museum of Art. See p. 53.

54 Paul Cézanne (1839–1906). *Mountains in Provence,* 1886–90. Oil on canvas, $25\frac{5}{8} \times 31\frac{7}{8}$ (65 × 81). Tate Gallery, London.

55 Paul Cézanne (1839–1906). *The Card Players, c.* 1885–90. Oil on canvas, $18\frac{3}{4} \times 22\frac{1}{2}$ (47.5 × 57). Louvre, Paris. See p. 53.

56 Paul Cézanne (1839–1906). *L'Estaque,* 1885. Oil on canvas, $28 \times 22\frac{3}{4}$ (71 × 56.5). Collection Lord Butler. See p. 53.

57 Paul Cézanne (1839–1906). *Still-life with Peppermint Bottle,* 1890–94. Oil on canvas, $25\frac{5}{8} \times 31\frac{7}{8}$ (65 × 76). National Gallery of Art, Washington, Chester Dale Collection. See p. 54.

58 Georges Seurat (1859–91). *Bridge at Courbevoie,* 1886–87. Oil on canvas, $18 \times 21\frac{1}{2}$ (46 × 54.5). Courtauld Institute Galleries, University of London. See p. 56.

59 Georges Seurat (1859–91). *Bathing at Asnières,* 1883–84. Oil on canvas, $79 \times 118\frac{1}{2}$ (201 × 301). Trustees of the National Gallery, London. See p. 56.

60 Philip Wilson Steer (1860–1942). *Girls Running, Walberswick Pier,* 1894. Oil on canvas, $24\frac{1}{2} \times 36\frac{1}{2}$ (62 × 93). Tate Gallery, London. See p. 56.

61 Paul Signac (1863–1955). *Debilly Footbridge, c.* 1926. Oil on canvas, $25\frac{5}{8} \times 31\frac{7}{8}$ (65 × 81). Private Collection, Geneva. See p. 56.

62 Vincent Van Gogh (1853–90). *Père Tanguy,* 1887. Oil on canvas, $36\frac{1}{4} \times 28\frac{3}{4}$ (92 × 73). Musée Rodin, Paris. See pp. 17–18, 57.

COVER Claude Monet (1840–1926). *Wild Poppies* (detail), 1873. Oil on canvas, $19\frac{5}{8} \times 25\frac{1}{2}$ (50 × 64.8). Louvre, Paris.

2

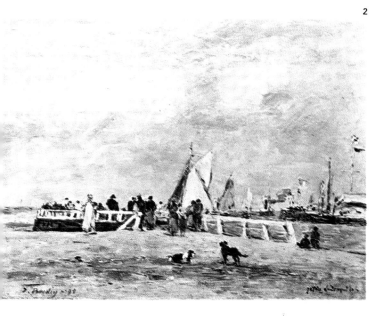

1

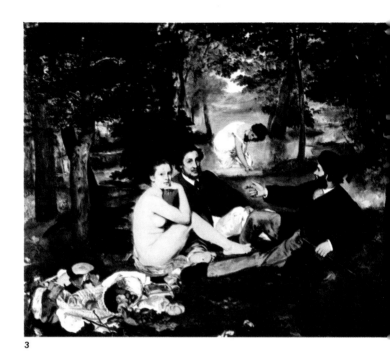

3

4

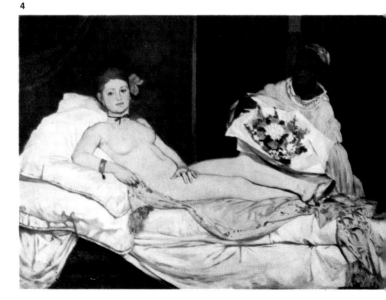

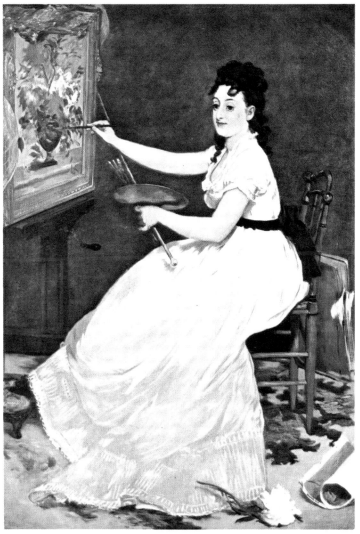

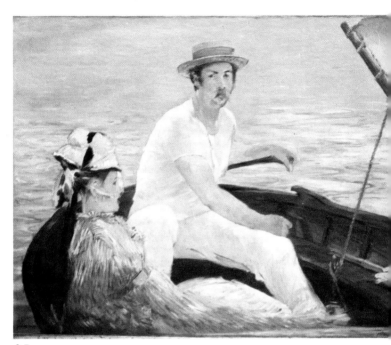

6-7

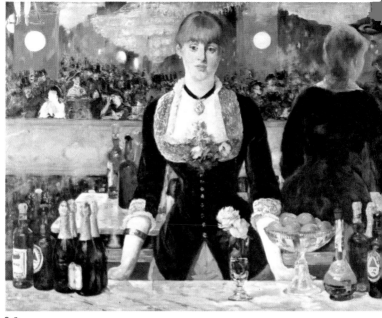

8-9

11

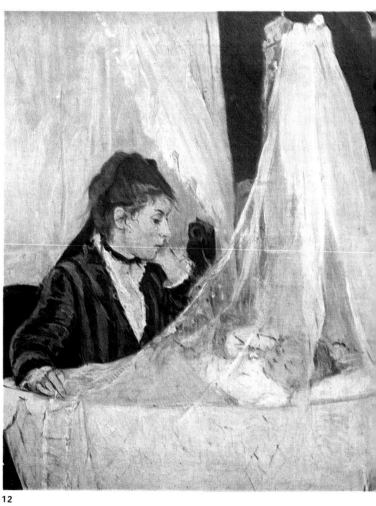

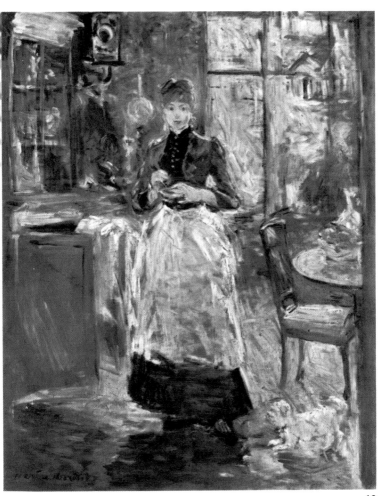

13

14

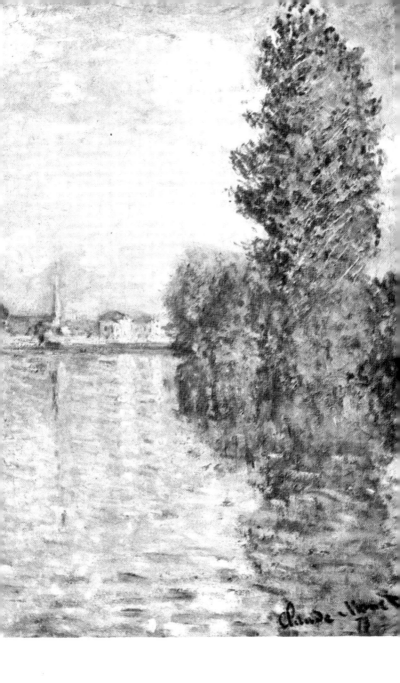

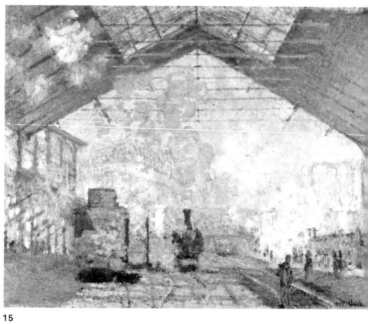

15

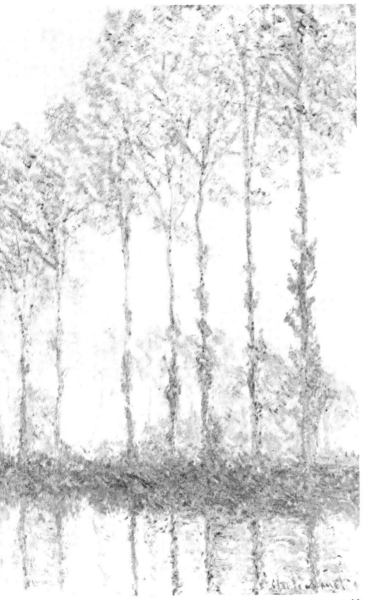

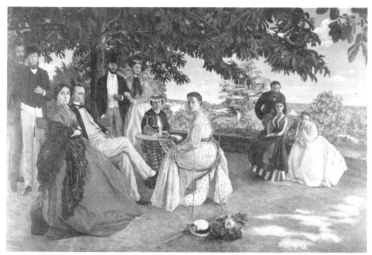

17-18

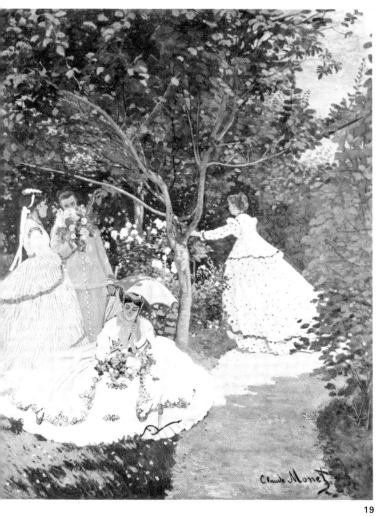

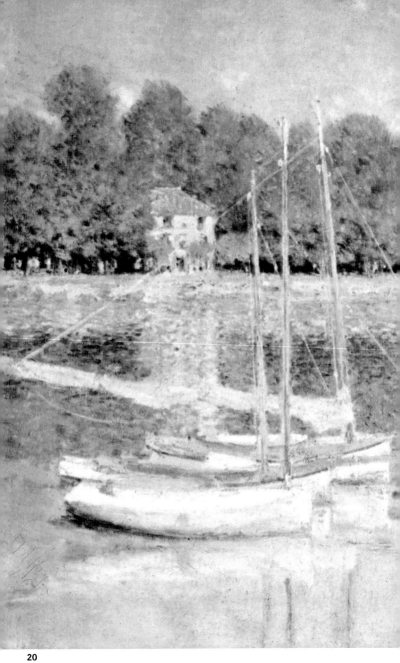

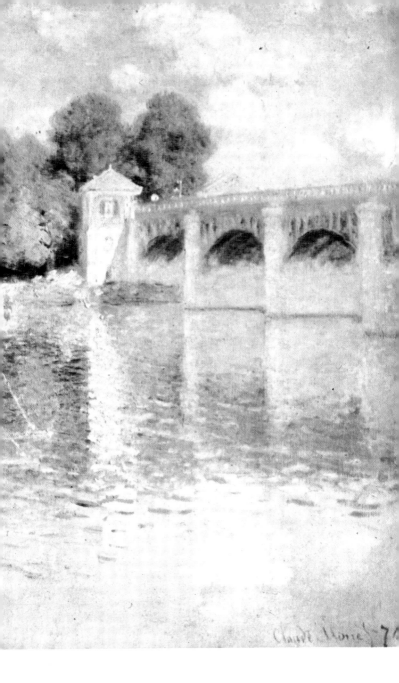

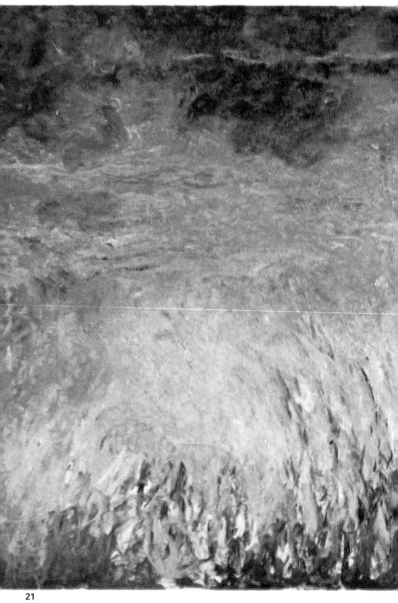

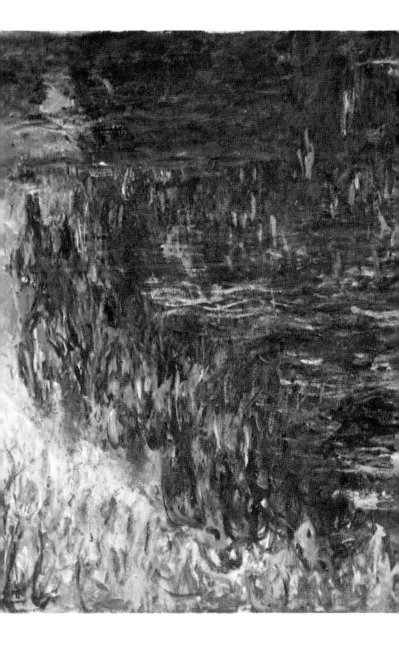

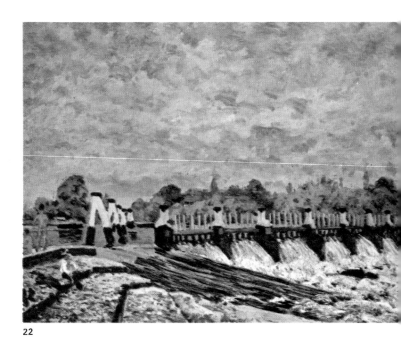

22

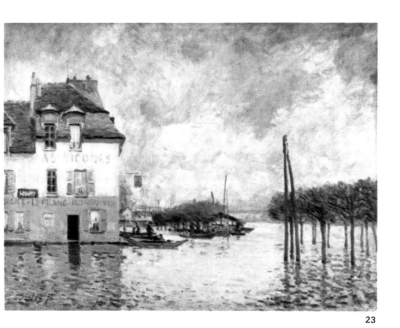

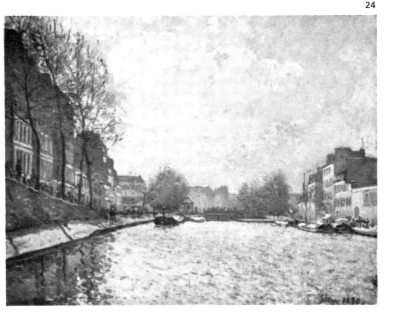

Sisley .74

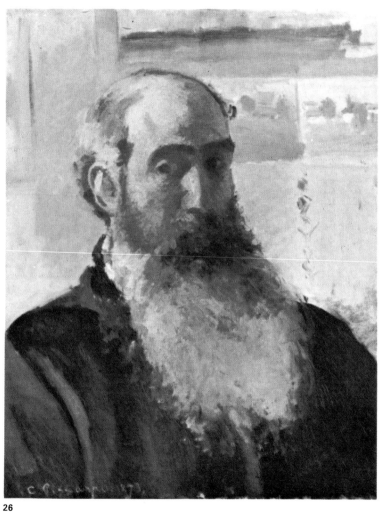

27

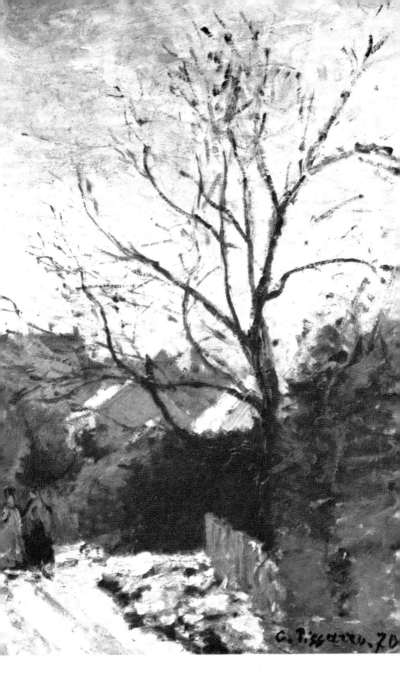

C. Pissarro. 70

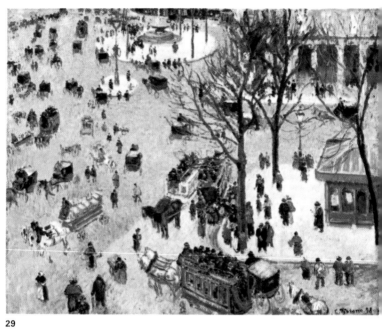

29

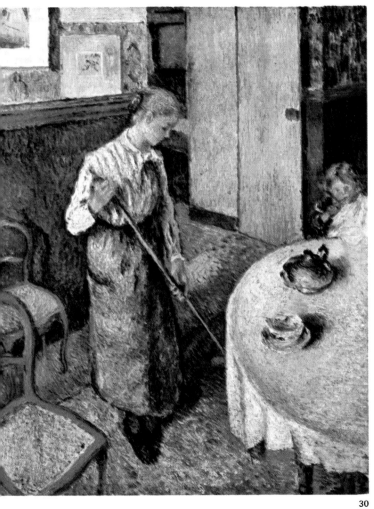

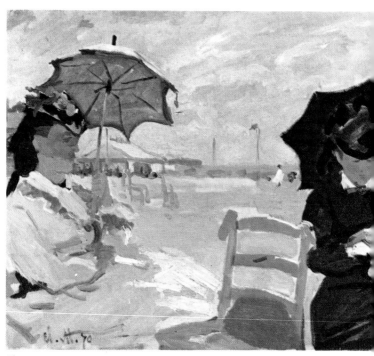

31

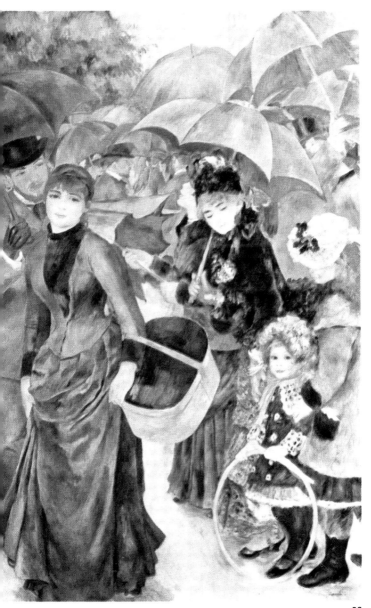

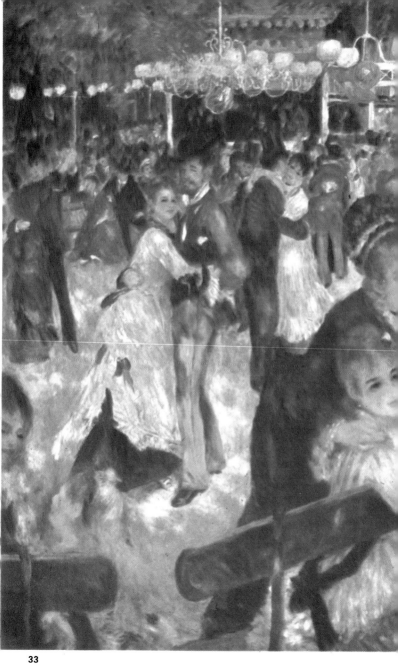

33

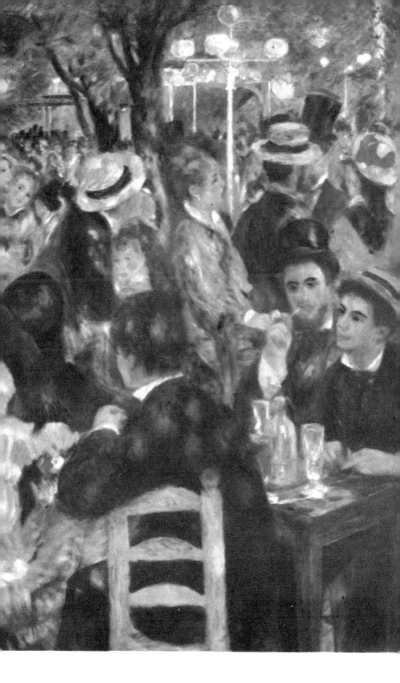

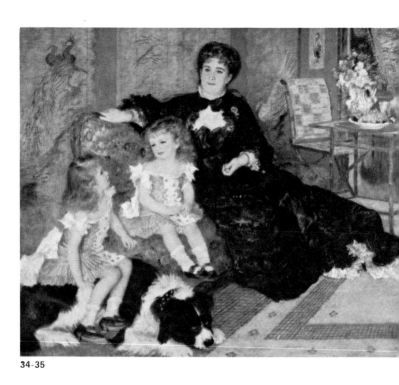

34-35

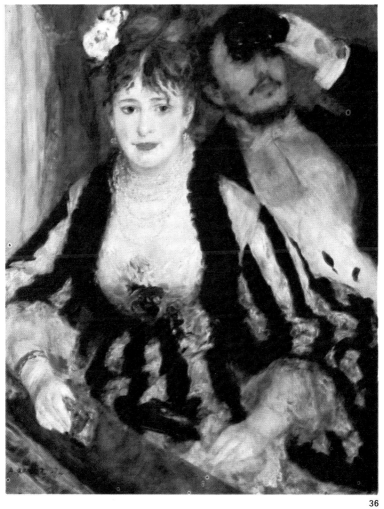

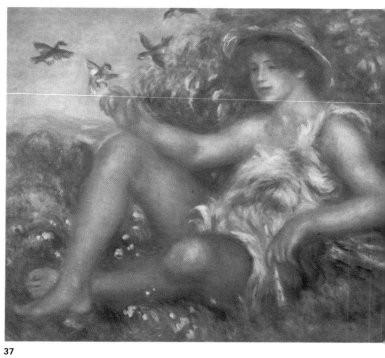

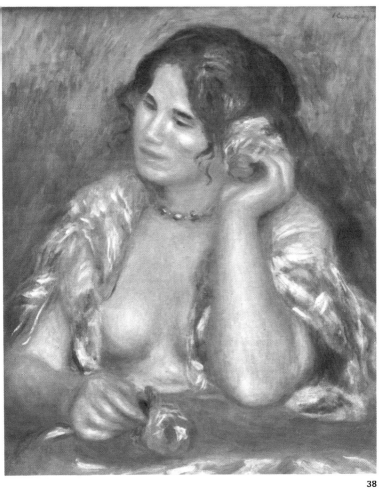

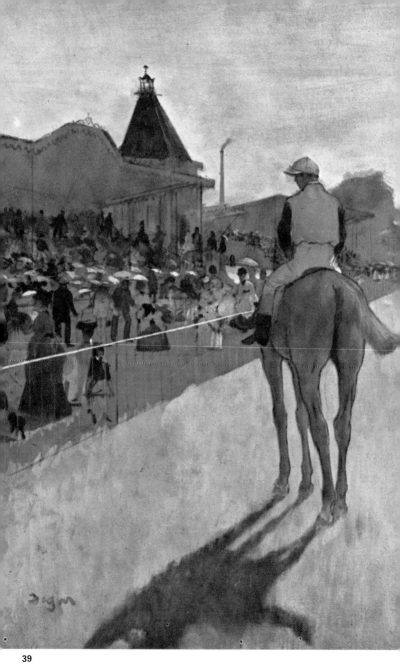

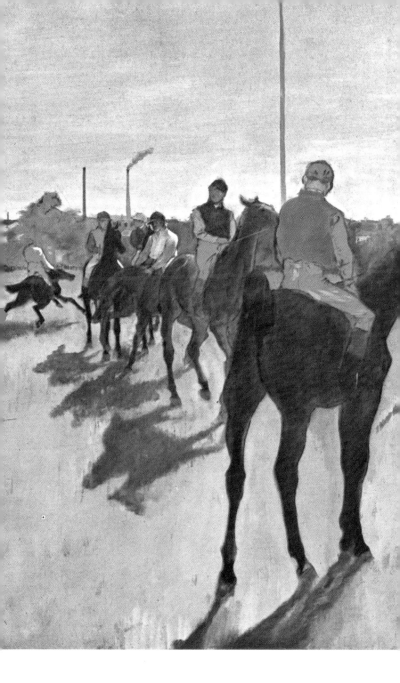

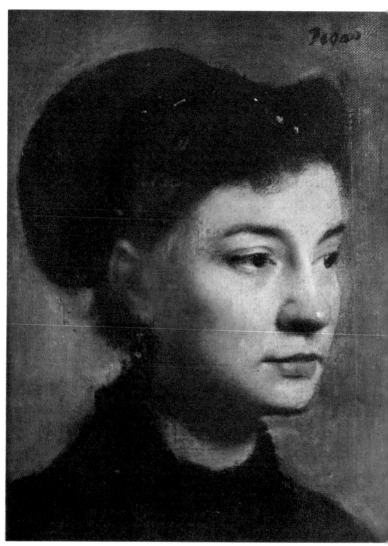

40

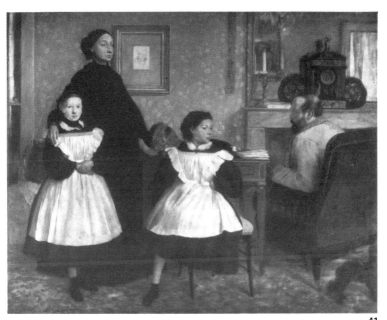

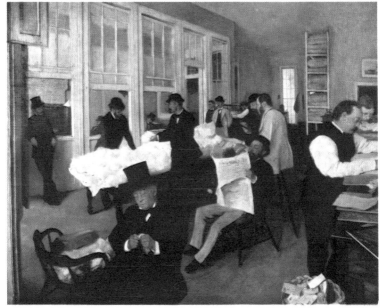

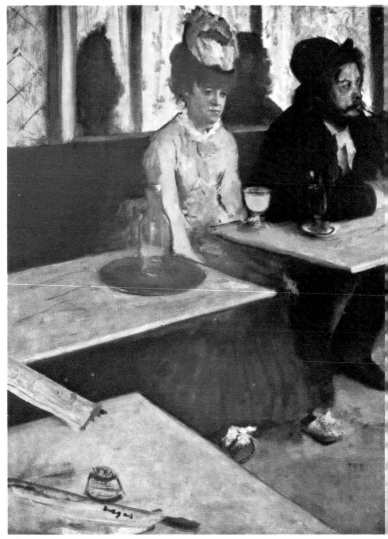

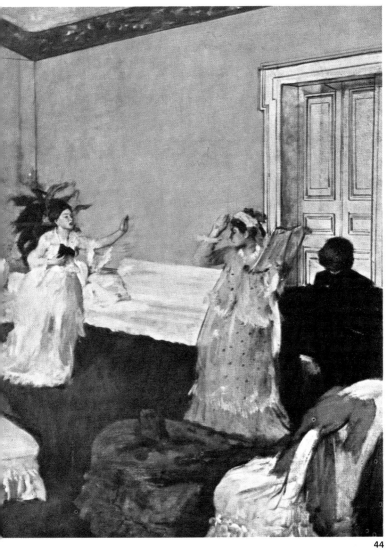

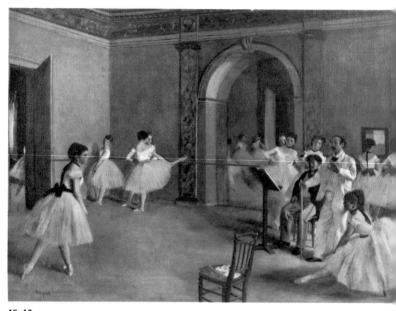

45-46

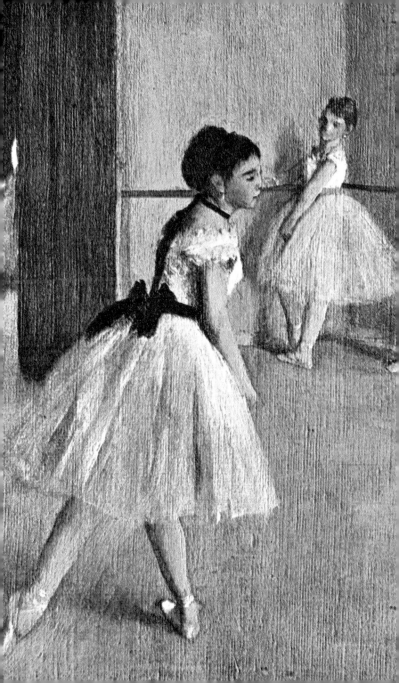

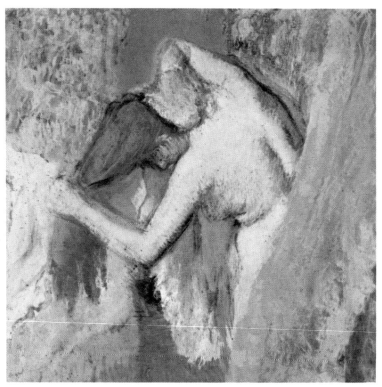

47

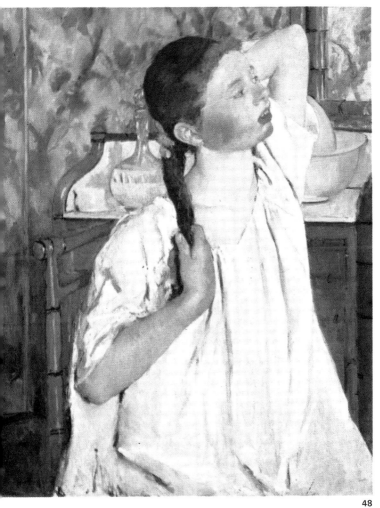

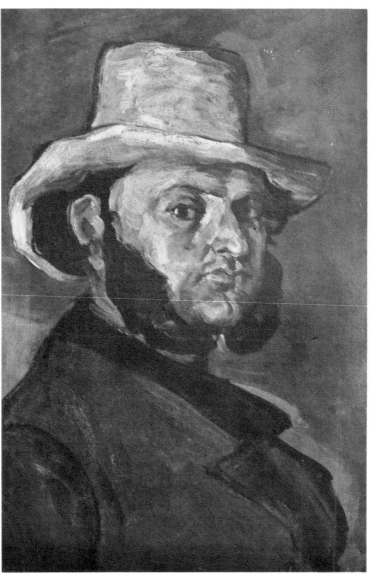

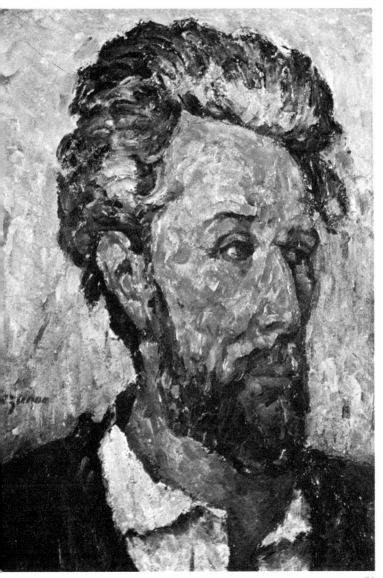

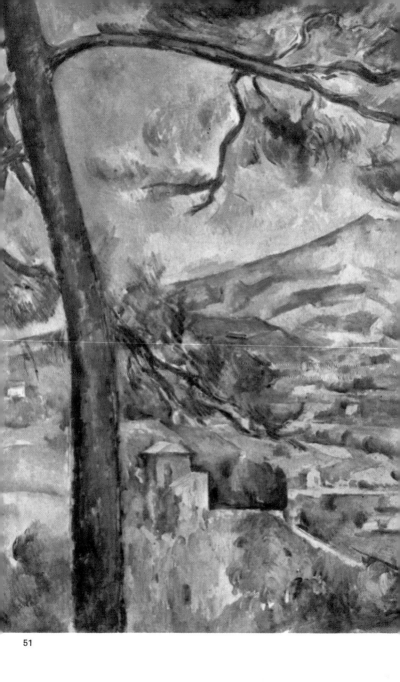

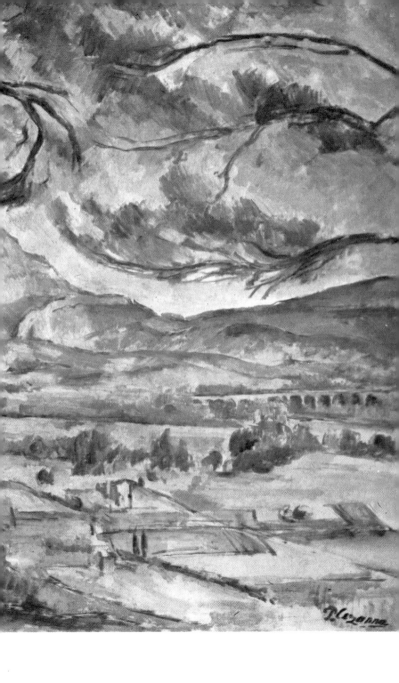

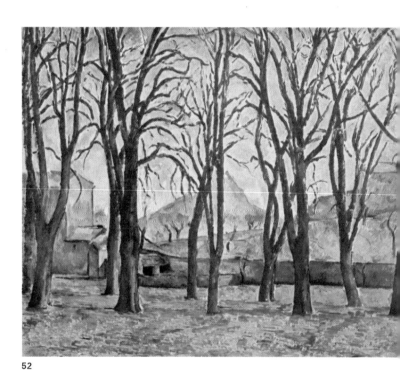

52

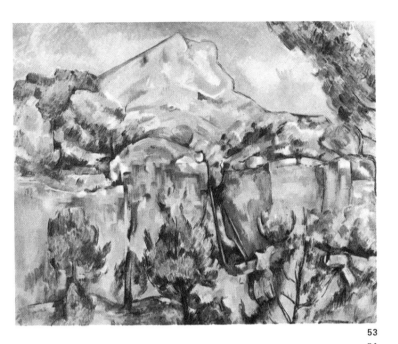

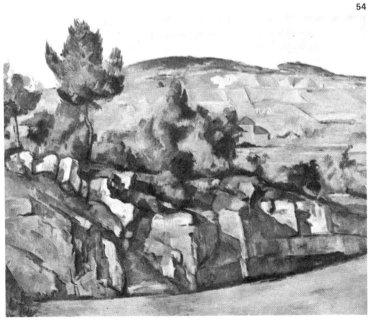

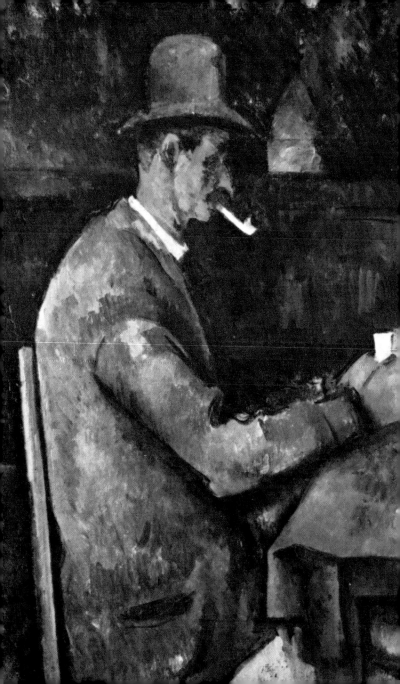

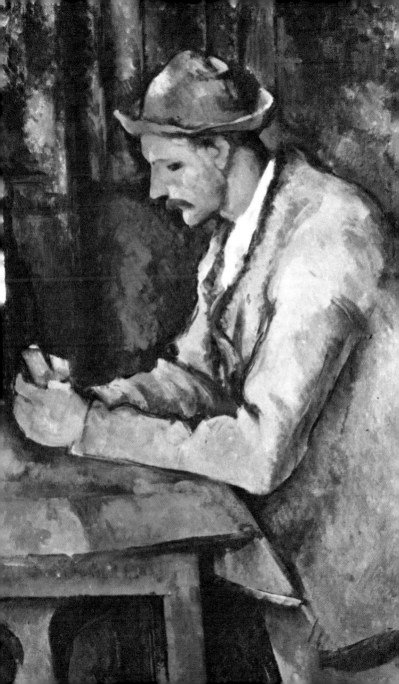

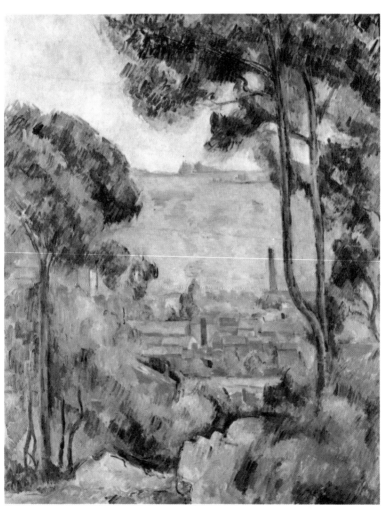

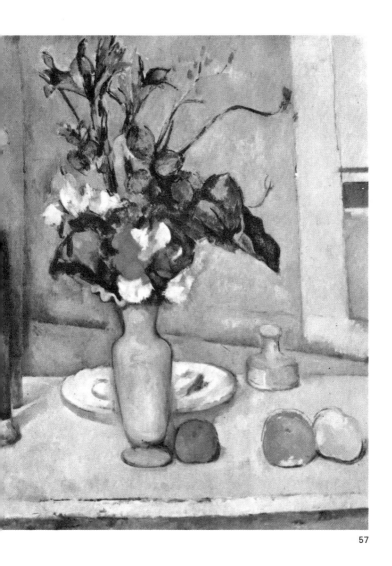

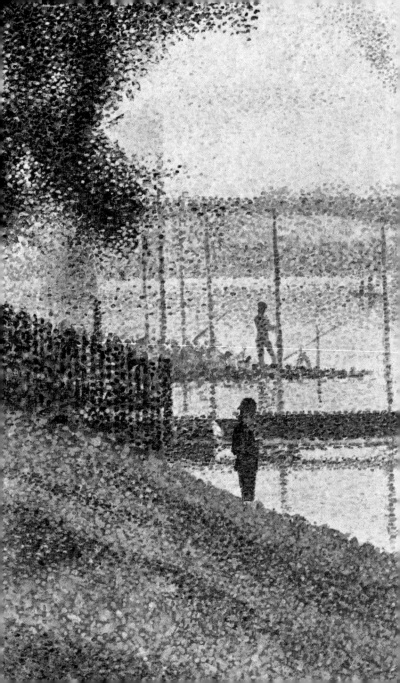

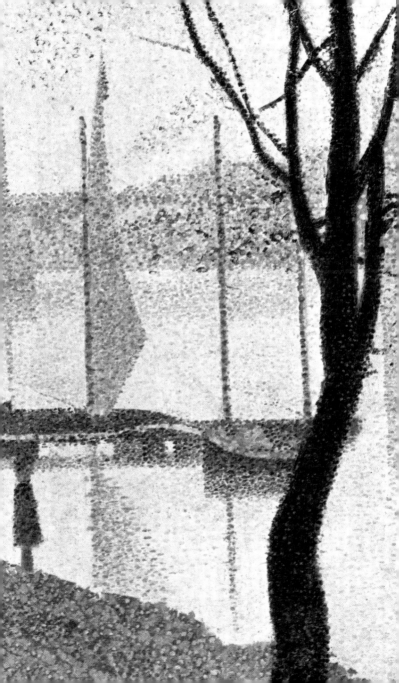

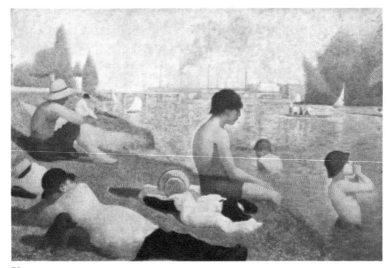

59

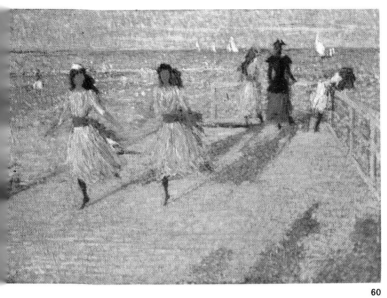

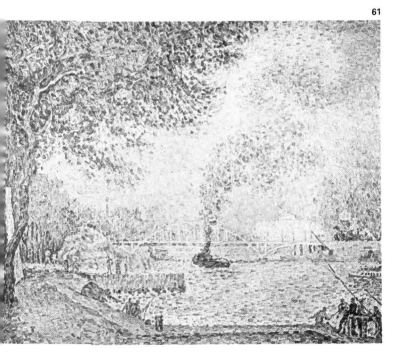

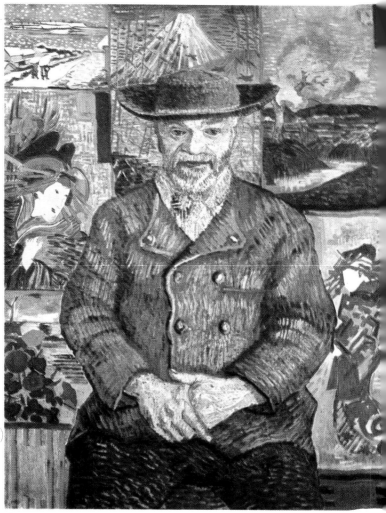